WOOD HOUSES

teNeues

Editor and texts: Joaquim Ballarín i Bargalló

Copy editing: Cristina Doncel

Layout: Ignasi Gracia Blanco

Translations: Richard Lewis Rees (English), Marion Westerhoff (French)
Susanne Engler (German), Maurizio Siliato (Italian)

Produced by Loft Publications
www.loftpublications.com

Published by teNeues Publishing Group

teNeues Publishing Company
16 West 22nd Street, New York, NY 10010, USA
Tel.: 001-212-627-9090, Fax: 001-212-627-9511

teNeues Book Division
Kaistraße 18
40221 Düsseldorf, Germany
Tel.: 0049-(0)211-994597-0, Fax: 0049-(0)211-994597-40

teNeues Publishing UK Ltd.
P.O. Box 402
West Byfleet
KT14 7ZF, Great Britain
Tel.: 0044-1932-403509, Fax: 0044-1932-403514

teNeues France S.A.R.L.
4, rue de Valence
75005 Paris, France
Tel.: 0033-1-55 76 62 05, Fax: 0033-1-55 76 64 19

teNeues Ibérica SL
Pso. Juan de la Encina 2-48, Urb. Club de Campo
28700 S.S.R.R., Madrid, Spain
Tel.: 0034-91-659-58-76

www.teneues.com

ISBN-10: 3-8327-9076-4
ISBN-13: 978-3-8327-9076-9

© 2005 teNeues Verlag GmbH + Co. KG, Kempen

Printed in Spain

Bibliographic information published by
Die Deutsche Bibliothek. Die Deutsche Bibliothek lists
this publication in the Deutsche Nationalbibliografie;
detailed bibliographic data is available in the Internet
at http://dnb.ddb.de.

Wood Houses: A Question of Scale

Holzhäuser: Eine Frage des Maßstabs

Maisons en bois : Question d'echelle

Casas de madera: Cuestión de escala

Case in legno: Questione di scala

Besides its recognized qualities as a decorative material, wood has other characteristics that make it a material of the future: It is perfectly sustainable, provided trees are felled selectively and systematically replanted; furthermore, it is immeasurably plentiful, requires little energy to be worked and generates no polluting residues. Constant research has led to major innovations and improvements: systems of joining and fixing, elements for paneled construction, mixed solutions and biocide treatments that mitigate the problem of durability. Wood is ideal for dry, prefabricated building. It is a light material, easily transported and handled and highly suitable for a market in which skilled labor is ever on the decrease. Perhaps its only limitation is size. Although materials such as wood in long gummed strips may cover large apertures and some pavilions of considerable dimensions have been built essentially of wood, it is on the domestic scale that this material seems to offer the greatest number of possibilities. This book presents a broad sample of single-family homes of many different types from all over the world.

Das Material Holz ist nicht nur sehr dekorativ, sondern es hat auch andere Eigenschaften, die es zu einem Material der Zukunft machen. Es handelt sich um ein absolut umweltgerechtes Material, wenn gezielt gefällt und systematisch aufgeforstet wird. Es ist ein Material, das nie zur Neige geht, für das nicht zu viel Energie bei Verarbeitung verbraucht wird und das keine schädlichen Rückstände hinterlässt. Aufgrund der ständigen Forschung und Entwicklung kommen immer wieder Neuheiten und Verbesserungen auf den Markt wie Verbindungs- und Befestigungssysteme, Elemente für die Konstruktion mit Paneelen, Mischlösungen und Biozidbehandlungen, die dieses Material immer haltbarer machen. Holz eignet sich ideal für die Fertigbauweise und trockenes Bauen, da es sich um ein leichtes, einfach zu transportierendes und zu handhabendes Produkt handelt. Es ist also besonders empfehlenswert für einen Markt, auf dem es immer schwieriger wird, Fachpersonal zu finden. Vielleicht ist die einzige Schwierigkeit, die es bei Holz als Baustoff gibt, die Größe, denn obwohl man mit Materialien wie verleimten Platten auch größere Flächen bedecken kann und relativ große Pavillons mit Holz errichtet wurden, ist Holz dennoch besser für den Bau von Wohnhäusern geeignet. In diesem Buch stellen wir viele verschiedene Typen von Einfamilienhäusern an unterschiedlichen Orten vor.

Outre ses qualités indéniables en tant que matériau de décoration, le bois en possède d'autres qui font de lui le matériau du futur : Il est parfaitement durable et renouvelable en tout temps à la suite d'une coupe sélective et d'une replantation systématique : c'est un matériau inépuisable dont la fabrication nécessite peu d'énergie et ne génère aucun résidu polluant. Les recherches constantes s'accompagnent d'innovations et d'améliorations : systèmes d'assemblage et de fixation, éléments constructifs à base de panneaux, solutions polyvalentes et traitements biocides qui n'affectent pas la durabilité. Le bois, utilisé pour la construction préfabriquée et sèche, est très adapté à la production légère. Facile à transporter et à manipuler, il est recommandé sur un marché où la main-d'œuvre se fait de plus en plus rare. Seules ses dimensions pourraient être un inconvénient car même si les matériaux constitués de bois en lamellé-collé permettent de couvrir de grandes surfaces et si le bois est le matériau de base utilisé dans la construction de pavillons aux dimensions considérables, c'est surtout à l'échelle de l'habitat privé que cet élément offre un maximum de possibilités. Ce livre présente une multitude d'exemples d'habitations individuelles aux typologie et origine géographique différentes.

Además de las cualidades indiscutibles como material decorativo, la madera presenta otras características que la convierten en un material con futuro: Es perfectamente sostenible, siempre y cuando se realice una tala selectiva y una replantación sistemática, y es un material inagotable que no precisa demasiada energía en su elaboración ni genera residuos contaminantes. Gracias a la constante investigación, aparecen novedades y mejoras: sistemas de unión y fijación, elementos para la construcción panelizada, soluciones mixtas y tratamientos biocidas que hacen de la durabilidad un problema menor. La madera permite una construcción prefabricada y seca, muy adecuada para un producto ligero, de fácil transporte y manipulación, y aconsejable en un mercado en el que, cada vez más, escasea la mano de obra cualificada. Tal vez la única limitación sea su tamaño; a pesar de que materiales como la madera laminada encolada posibilitan el cubrimiento de grandes luces y de que algunos pabellones de dimensiones considerables utilizan como base la madera, al parecer, es en la escala doméstica donde este elemento ofrece las máximas posibilidades. Este libro muestra múltiples ejemplos de viviendas unifamiliares de tipología y origen geográfico distintos.

Oltre alle indiscutibili qualità come materiale decorativo, il legno presenta altre caratteristiche che lo trasformano in un materiale del futuro. È perfettamente sostenibile, a patto che si realizzi un disboscamento e un trapianto sistematico; è un materiale inesauribile che non ha bisogno di molta energia per la sua elaborazione né genera residui contaminanti. Grazie alla ricerca costante, si scoprono novità e miglioramenti: sistemi di unione e fissaggio, elementi per strutture pannellate, soluzioni miste e trattamenti con biocidi che riducono il problema della durabilità. Il legno consente un tipo di costruzione prefabbricata e asciutta, molto adeguata a un prodotto leggero, facile da trasportare e lavorare, e consigliabile in un mercato in cui la mano d'opera qualificata scarseggia sempre di più. Probabilmente l'unico limite è dato dalle sue dimensioni: nonostante materiali come il legno laminato incollato rendano possibile il rivestimento di grandi vani e che alcuni padiglioni di notevoli dimensioni utilizzino come base il legno, a quanto pare, è in ambito domestico dove questo elemento offre maggiori possibilità. Questo libro mostra molteplici esempi di abitazioni unifamiliari di tipologia e origini geografiche diverse.

Solid Wood Houses

Holzhäuser aus Massivholz

Maisons en bois massif

Casas de madera maciza

Case in legno massiccio

The oldest construction system applied to wood houses consists of piling up trunks horizontally, having previously removed the bark, and assembling them at the corners of the building. The first houses of this kind appeared in northern European countries where wood was plentiful, and then spread to the rest of the world as part of the colonization process, particularly to those countries with plentiful raw material, such as America, South Africa, New Zealand and Australia. With the emergence of the first sawmills, builders began to optimize the preparation and utilization of tree trunks and standardize their measurements. Today, this process has become highly sophisticated to the point of near perfection. Almost the entire process is carried out in the workshop, offering builders a completely prefabricated product so that all they have to do is assemble it on site. Despite being composed primarily of wood, this system confers a certain rigidity similar to the effect produced by load-bearing walls. The almost exclusive implementation of wood generates exceptionally attractive surfaces, while the material continuity provides greater insulation and thermal inertia. The houses that follow are a clear example of this.

Das älteste System zum Bau von Holzhäusern bestand darin, die Stämme horizontal übereinander zu schichten, nachdem vorher die Rinde entfernt wurde. Diese Stämme wurden dann an den Ecken des Hauses zusammengefügt. Die ersten Häuser errichtete man in den Ländern Nordeuropas, in denen es reichlich Holz gab, und die Siedler trugen dieses System in die ganze Welt. In vielen Regionen mit ausreichend Rohstoff wie Amerika, Südafrika, Neuseeland und Australien werden Holzhäuser gebaut. Als die ersten Sägewerke entstanden, begannen die Baumeister die Stämme mehr und besser zu bearbeiten und die Verwendung des Rohmaterials zu verbessern. Auch die Maße wurden genormt. In der Gegenwart ist das Verarbeitungssystem für Holz sehr weit entwickelt. Fast der ganze Prozess findet in der Werkstatt statt und dem Bauunternehmer wird ein vollständig vorgefertigtes Produkt angeboten, das an der Baustelle nur noch montiert werden muss. Das System gibt dem Bau Festigkeit und das Ergebnis gleicht dem, das man erreicht, wenn man ein Gebäude mit tragenden Mauern aus Stein errichtet. Außerdem sind die Wände aus Massivholz besonders schön und die Häuser, die vollständig aus Holz gefertigt sind, weisen sehr gute Eigenschaften in Bezug auf die thermische Isolierung und Trägheit auf. Die Häuser, die wir Ihnen im folgenden vorstellen, sind gute Beispiele für die erwähnten Vorteile.

Le plus ancien système de construction de maisons en bois consiste à empiler les troncs horizontalement, après en avoir, au préalable, ôter l'écorce pour les assembler ensuite dans les angles de l'édifice. Les premières maisons apparaissent dans les pays du Nord de l'Europe, où le bois abonde, pour s'étendre au reste du monde par le biais des colonisateurs, notamment dans les pays où cette matière première est en quantité suffisante, à l'instar de l'Amérique, l'Afrique du Sud, la Nouvelle Zélande et l'Australie. Dès l'apparition des premières scieries, les constructeurs commencent à travailler davantage les troncs, à optimiser l'emploi de cette matière première et à en standardiser les mesures. De nos jours, le système de fabrication s'est considérablement perfectionné pour devenir plus sophistiqué. L'ensemble du processus se déroule à l'atelier, offrant au constructeur un produit final entièrement préfabriqué qu'il ne reste plus qu'à assembler sur place. Le système permet d'obtenir une construction rigide. En effet, on se rapproche beaucoup de l'effet obtenu par la construction avec des murs de soutien. Cela mis à part, l'emploi presque exclusif du bois crée des parements solides d'une grande beauté esthétique et la continuité du matériau offre des capacités d'isolement et d'inertie thermique plus fiables. Les habitations présentées ici en sont l'exemple parfait.

El sistema más antiguo de construcción de casas de madera consiste en apilar los troncos horizontalmente, tras haber retirado previamente la corteza, y ensamblarlos en las esquinas del edificio. Las primeras casas aparecen en países con abundante madera, en el norte de Europa, y se extienden al resto del mundo a través de los colonizadores. Lo hacen a países con suficiente materia prima, como América, Sudáfrica, Nueva Zelanda y Australia. Cuando aparecen los primeros aserraderos, los constructores empiezan a trabajar más los troncos, a optimizar el empleo de la materia prima y a estandarizar sus medidas. En la actualidad, el sistema de elaboración se ha perfeccionado considerablemente y es mucho más sofisticado. Casi todo el proceso se lleva a cabo en el taller y se ofrece al constructor un producto completamente prefabricado que simplemente tiene que montarse en el emplazamiento final. El sistema proporciona cierta rigidez a la construcción, y el resultado se aproxima bastante a la edificación con muros de carga. A pesar de ello, el empleo casi exclusivo de la madera genera paramentos macizos de gran belleza estética y la continuidad material proporciona un aislamiento e inercia térmica más fiables. Las viviendas que se muestran a continuación son un claro ejemplo de ello.

Il più antico sistema di costruzione di case in legno consiste nell'impilare i tronchi orizzontalmente, dopo aver rimosso previamente la corteccia, e assemblarli agli angoli dell'edificio. Le prime case compaiono in paesi dove vi è legno in abbondanza, nel nord Europa, dopodiché l'uso si diffonde nel resto del mondo ad opera dei colonizzatori. La diffusione interessa paesi con sufficienti materie prime quali l'America, il Sudafrica, la Nuova Zelanda e l'Australia. Con la comparsa delle prime segherie, i costruttori iniziano a lavorare di più i tronchi, a ottimizzare l'uso della materia prima e a standardizzare le sue dimensioni. Attualmente, il sistema di elaborazione si è perfezionato notevolmente ed è molto più sofisticato. Quasi tutto il processo avviene presso la fabbrica e al costruttore viene offerto un prodotto completamente prefabbricato che deve semplicemente montarsi nell'ubicazione finale. Il sistema apporta una certa rigidità alla costruzione visto che ci si avvicina molto all'effetto prodotto da un edificio con muri di sostegno. Ciò nonostante, l'uso quasi esclusivo del legno genera parametri di legni massicci di grande bellezza estetica e la continuità materiale conferisce caratteristiche di isolamento ed inerzia termica più affidabili. Le abitazioni che si mostrano di seguito ne sono un chiaro esempio.

House in Flawil

Architects: Markus Wespi, Jérôme de Meuron Architekten

Location: Flawil, Switzerland

Year: 2000

Photography: Hannes Henz

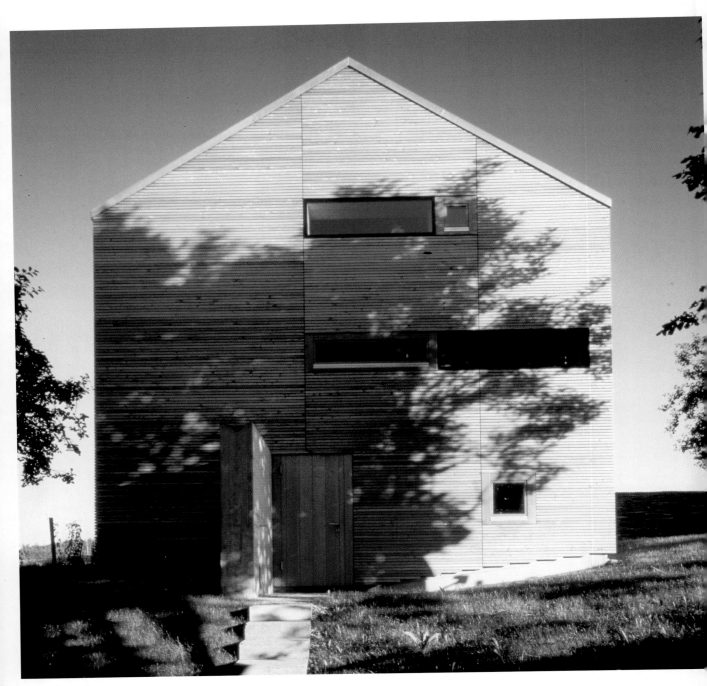

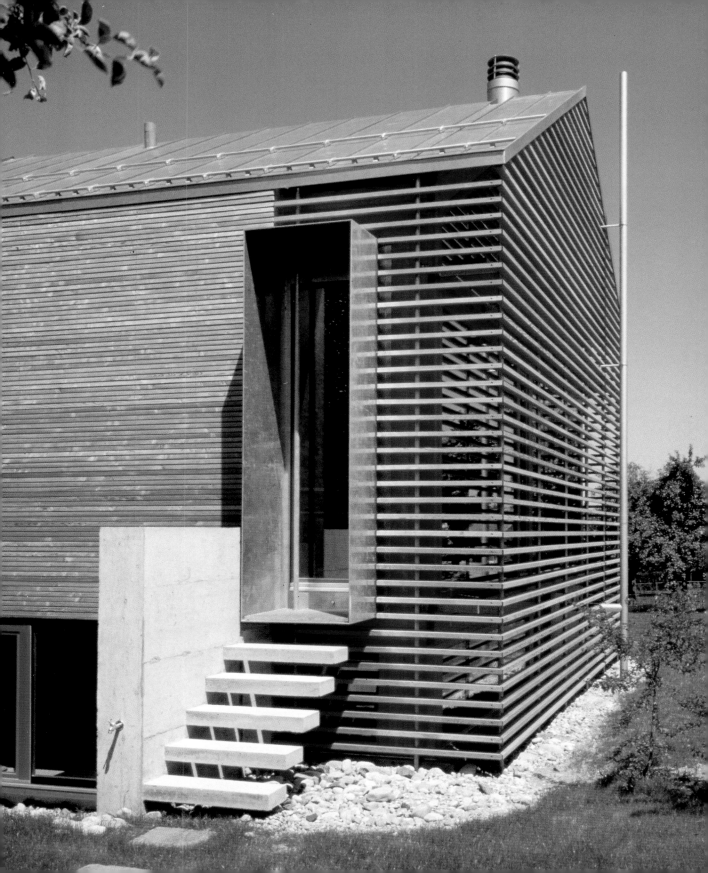

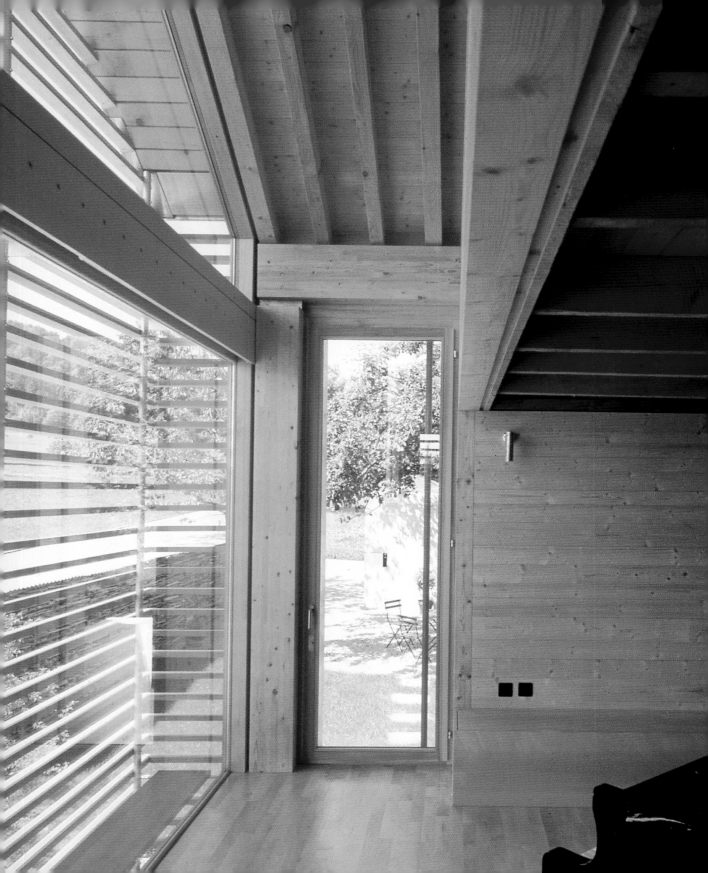

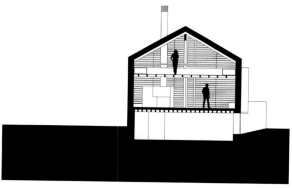

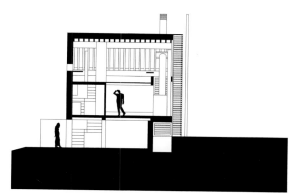

Sections

Restoration of a prefabricated wood house focuses on filtering the light through systems of slats and rediscovering the original wood, which had been concealed for years.

Die Restaurierung dieses Fertigholzhauses hatte zum Ziel, das Licht mithilfe eines Systems aus Lamellen zu filtern und das Holz der Originalstruktur, das jahrelang verdeckt war, wieder freizulegen.

L'amélioration d'une maison en bois préfabriquée sont axées sur la filtration de la lumière grâce à des systèmes de lamelles. Cette restauration permet de faire réapparaître le bois original, masqué pendant des années.

La reforma de una vivienda prefabricada de madera concentra su esfuerzo en filtrar la luz mediante sistemas de lamas y redescubre la madera original, oculta durante años.

I nuovi lavori di ristrutturazione di un'abitazione prefabbricata in legno hanno avuto come obiettivo primordiale far filtrare la luce mediante dei sistemi lamellari e mettere in risalto il legno originale, rimasto nascosto per tanti anni.

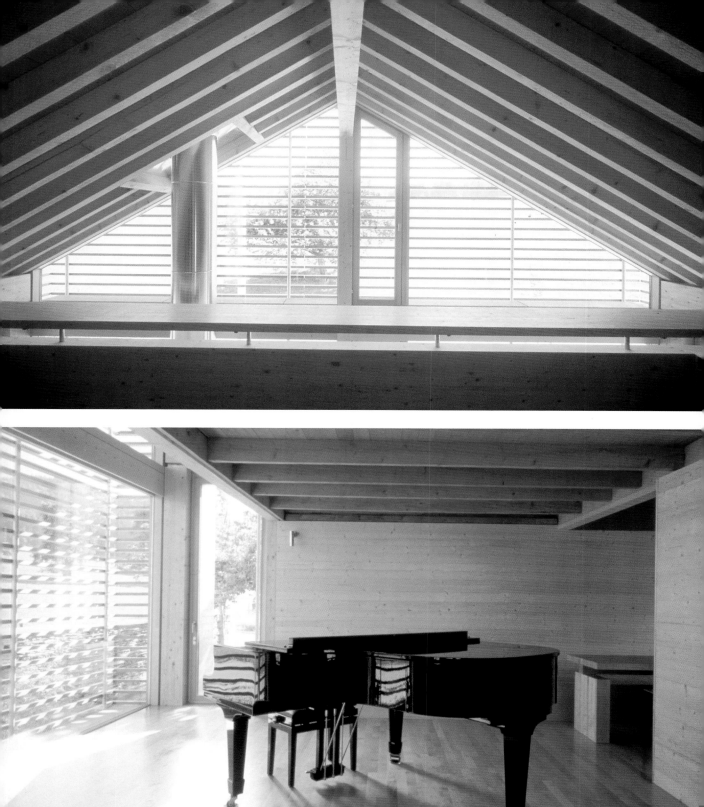

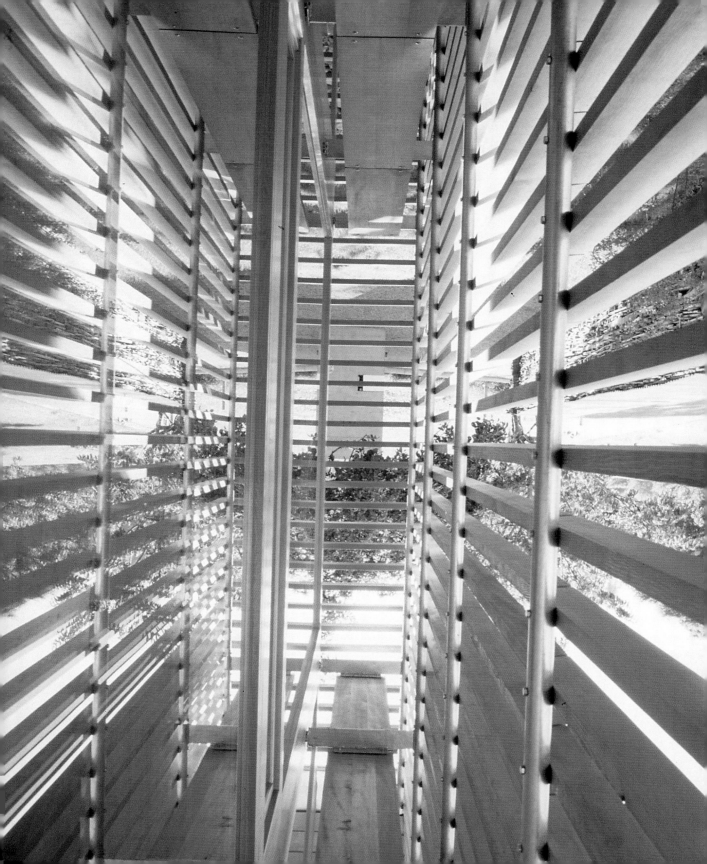

Hein House

Architect: Cukrowicz.Nachbaur Architekten
Location: Fraxern, Austria
Year: 2000
Photography: Albrecht Immanuel Schnabel

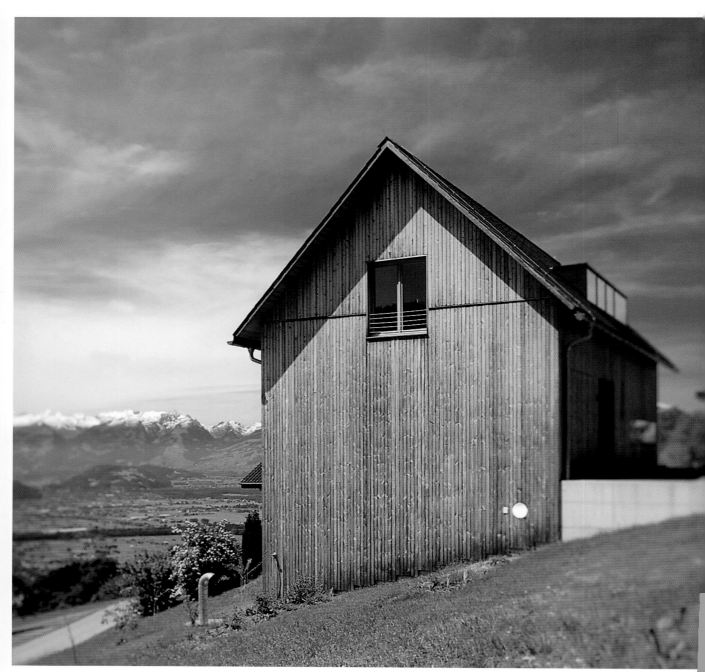

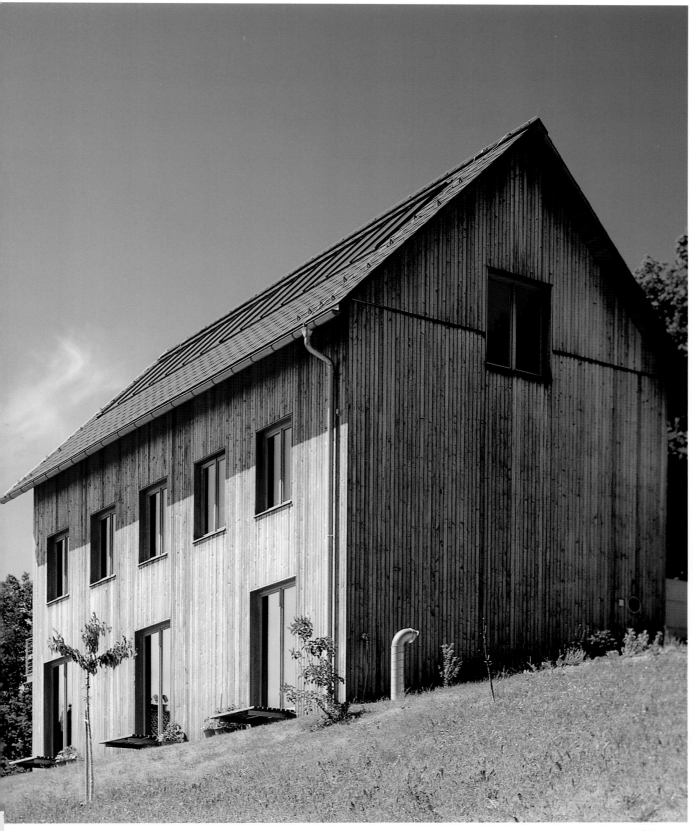

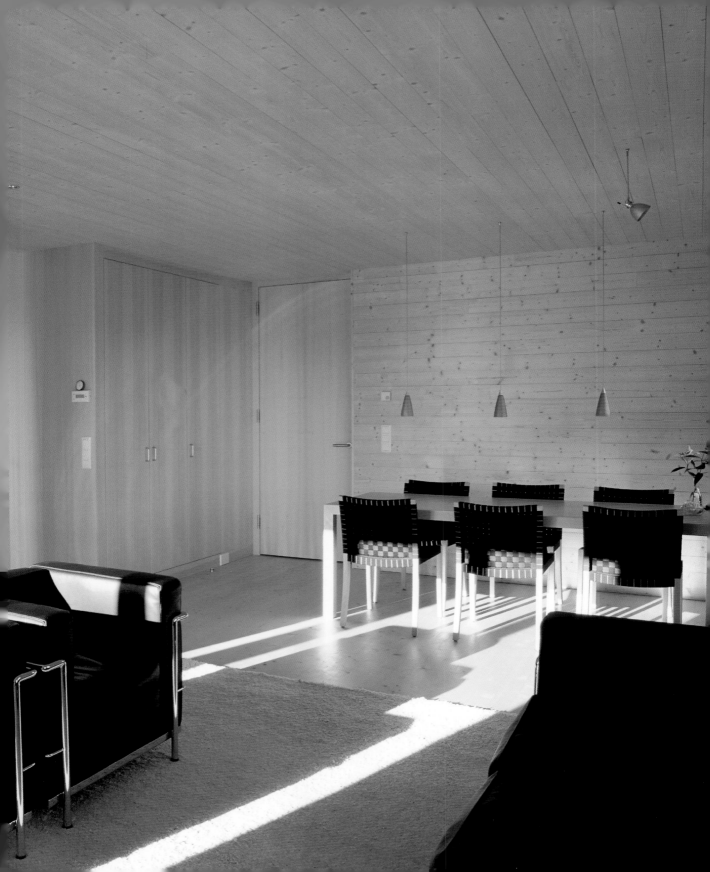

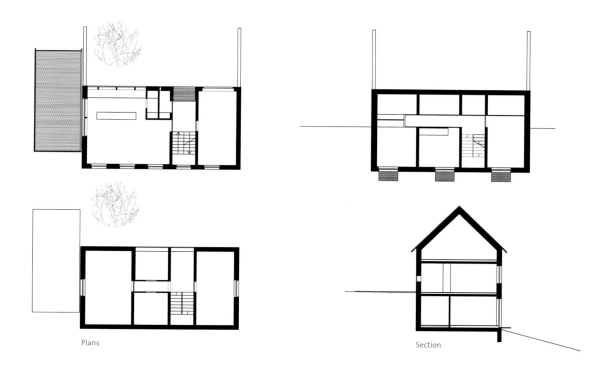

Plans Section

A terrace of striking forms encompasses a house of solid wood, introverted and cautious, and serves as a springboard from which to leap toward the potent views of the slope.

Eine Terrasse umgibt und umschließt dieses verschlossene und schlichte Haus aus massivem Holz und bildet eine Art Sprungbrett, von dem aus man sich in die Lüfte schwingt und den beeindruckenden Blick auf den Abhang genießt.

Une terrasse aux formes rigides parcourt et enveloppe une maison de bois massif, tournée vers l'intérieur et secrète, à l'instar d'un tremplin pour s'élancer vers les vues grandioses du coteau.

Una terraza de formas rotundas recoge y envuelve una casa de madera maciza, introvertida y cauta, que la utiliza como trampolín para lanzarse a las poderosas vistas de la ladera.

Una terrazza dalle forme nette ospita e avvolge una casa in legno massiccio, introversa e discreta che a sua volta la utilizza come trampolino per tuffarsi nelle meravigliose viste del pendio.

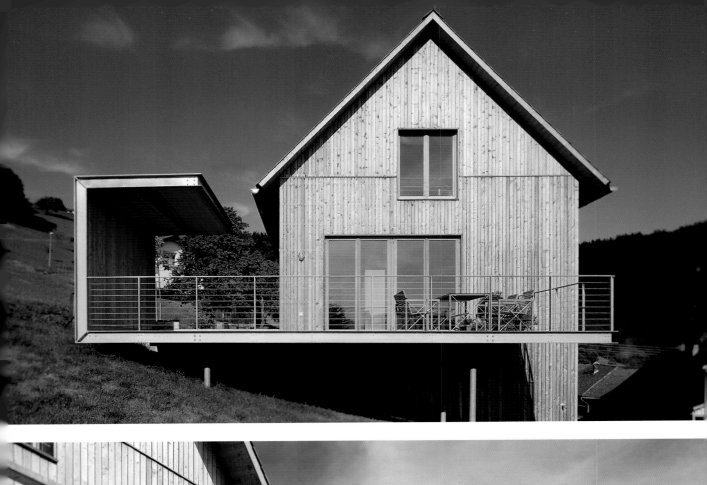
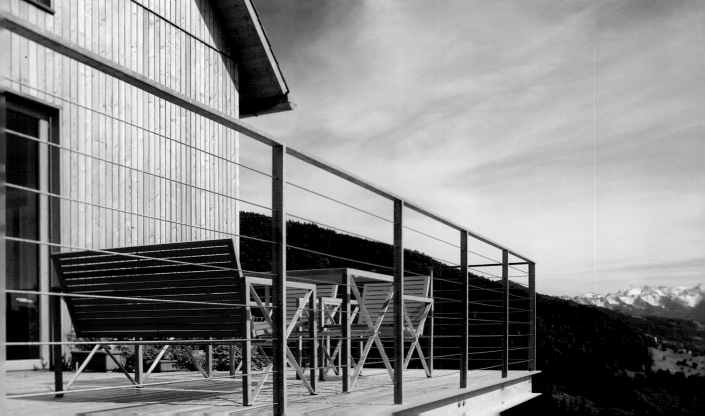

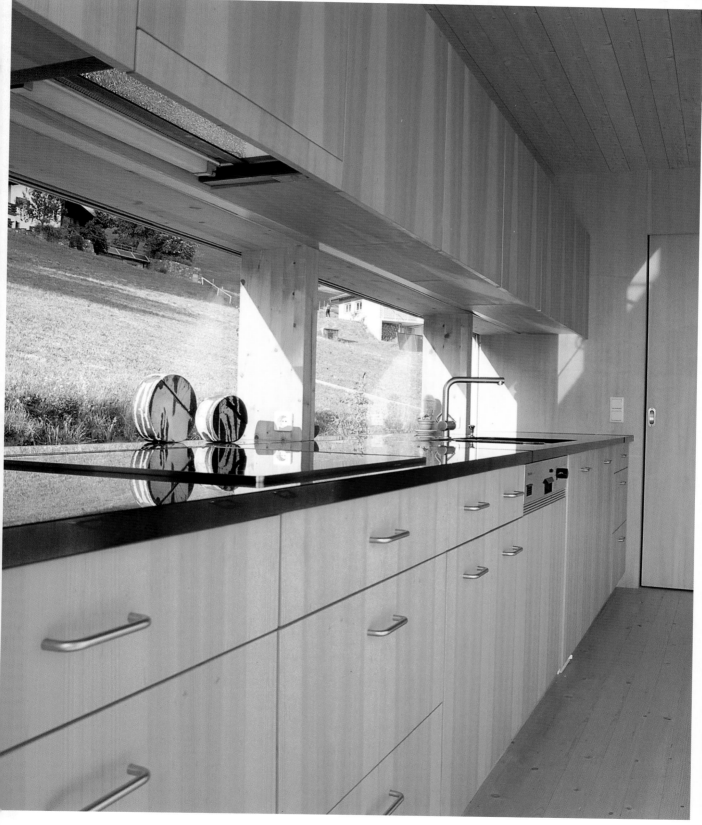

Tracy House

Architects: Joaquim Ballarín i Bargalló, Esma Bouchenak-Khelladi/Estudi Arca d'Arquitectura
Josep Auguet, Angel Rodríguez and Alberto Garcés Pérez
Location: Subirats, Spain
Year: 2005
Photography: Javier Esparza Sirera

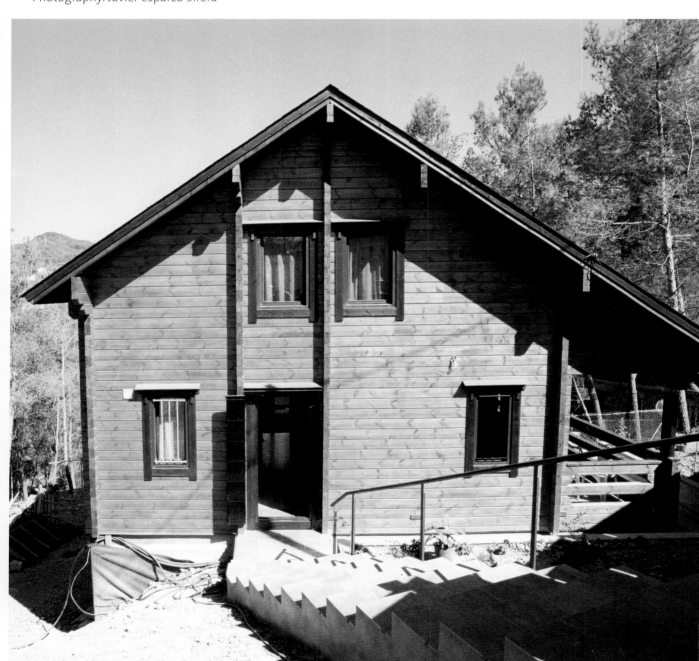

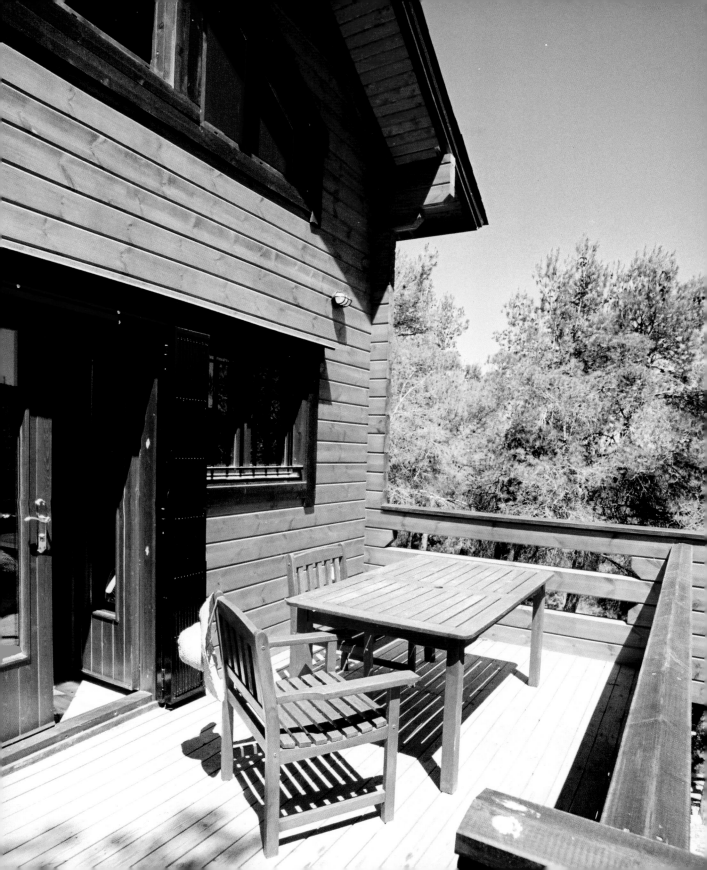

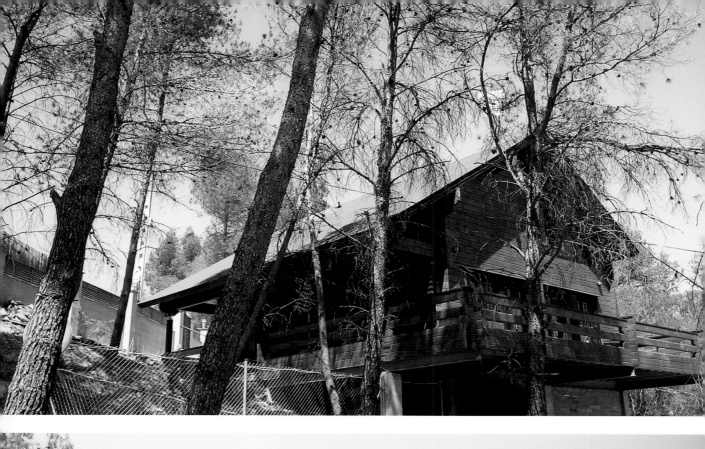
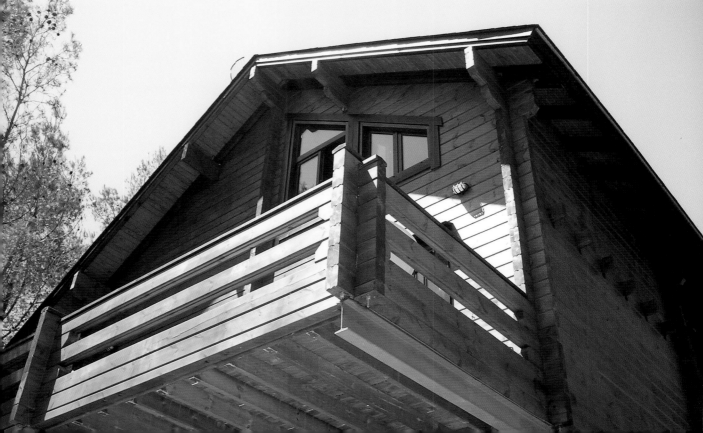

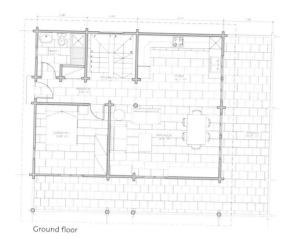

Ground floor

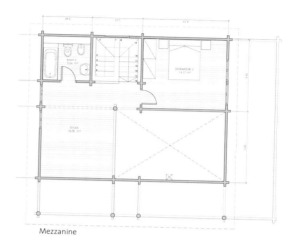

Mezzanine

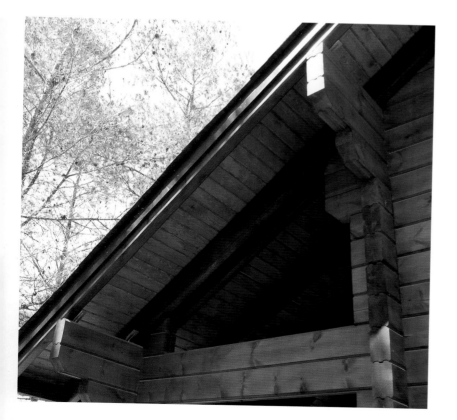

A house built entirely from trunks, highly conventional on the exterior but with a very rich interior thanks to the relationships between spaces through double heights.

Dieses Haus ist vollständig aus Stämmen konstruiert. Von außen wirkt es sehr konventionell, aber das Innere ist alles andere als langweilig dank der offenen Geschosse, die Verbindungen zwischen den Räumen ermöglichen.

Maison construite entièrement en troncs, très conventionnelle à l'extérieur, dotée d'un intérieur magnifique grâce aux relations spatiales par le biais de double hauteurs.

Casa construida íntegramente con troncos, exteriormente convencional, con un interior muy rico gracias a las relaciones de espacios a través de dobles alturas.

Casa costruita interamente con tronchi, dall'aspetto esterno molto convenzionale, e con degli interni molto ricchi grazie ai rapporti spaziali creati mediante le doppie altezze.

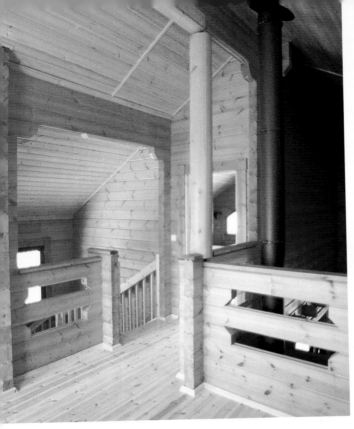
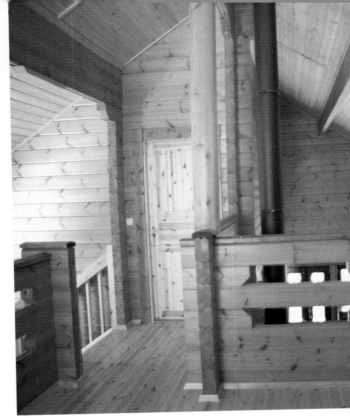
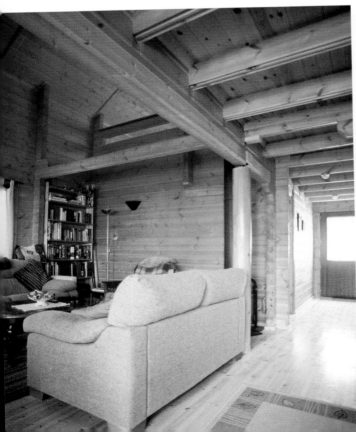
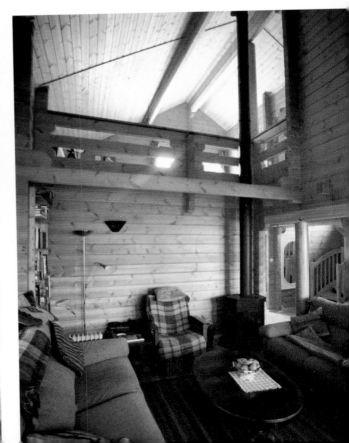

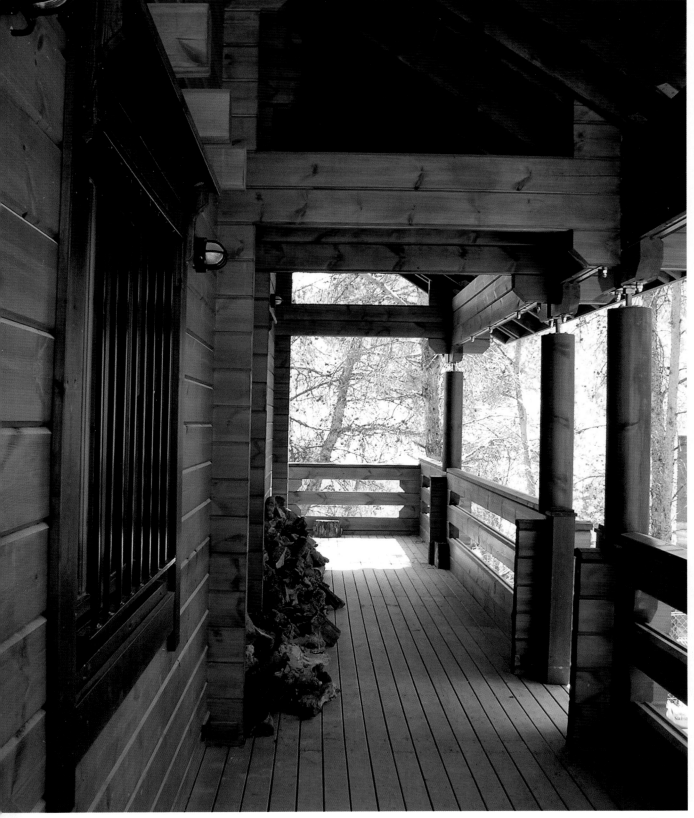

Steger House

Architect: Gerold Leuprecht
Collaborators: Berchtold Holzbau
Location: Schwarzach, Linzenberg, Austria
Year: 2004
Photography: Ignacio Martínez

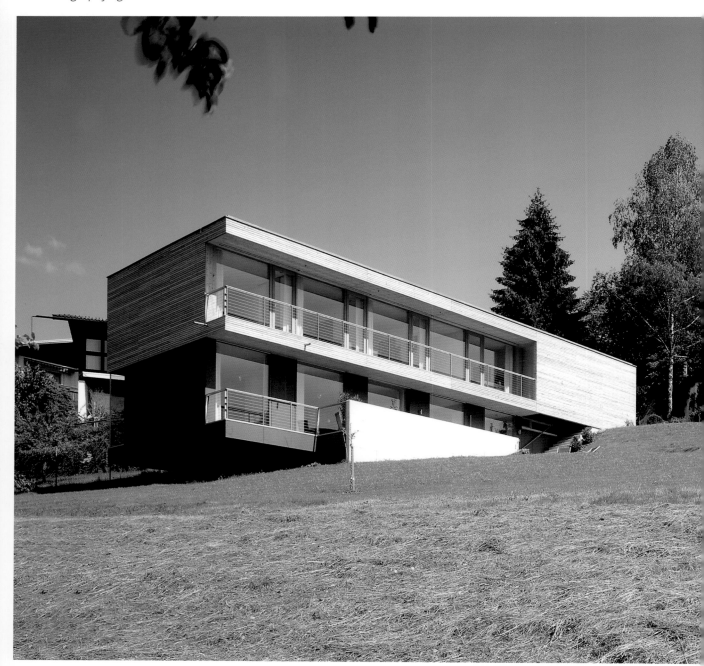

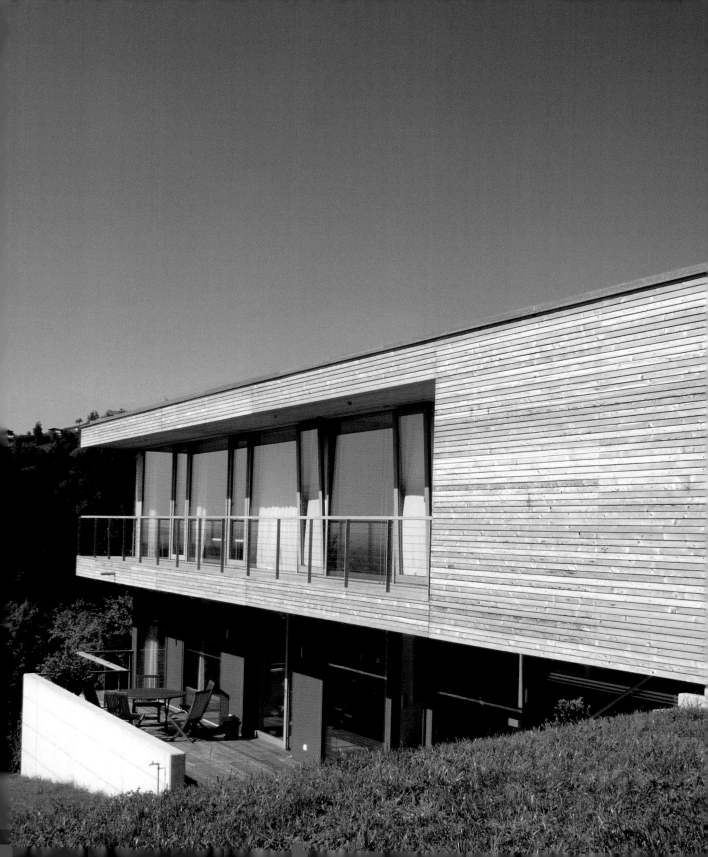

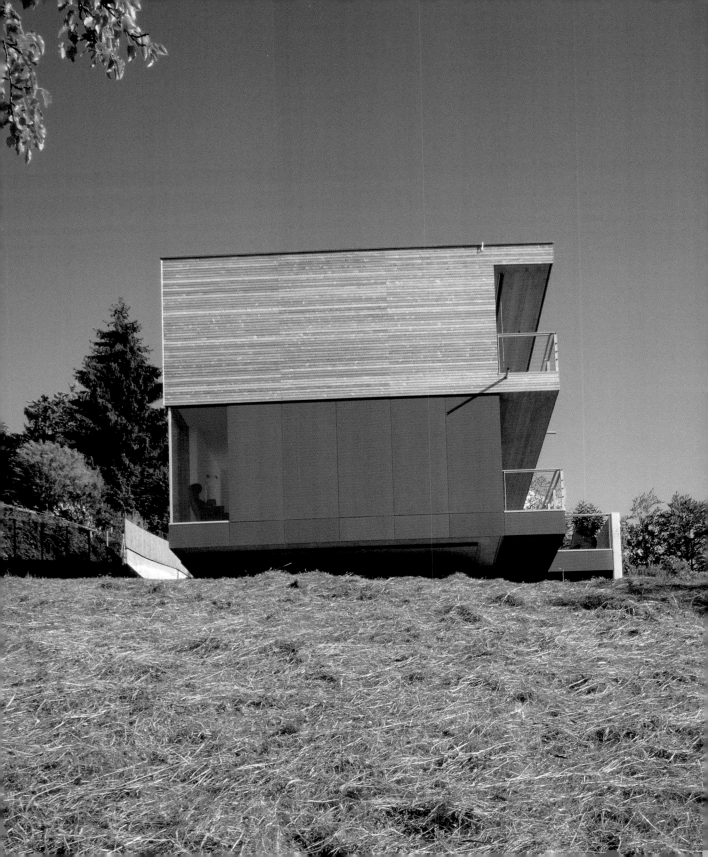

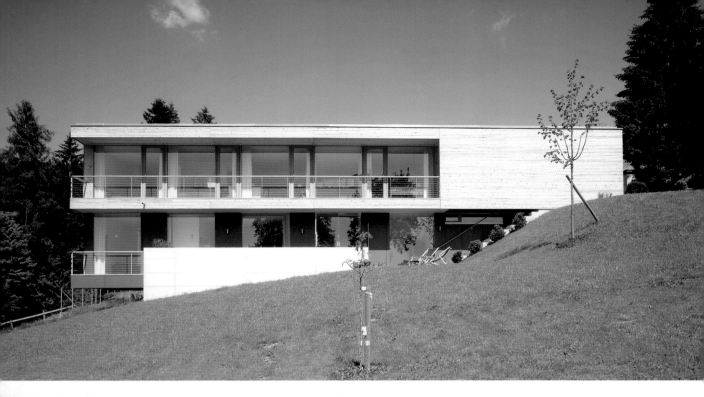

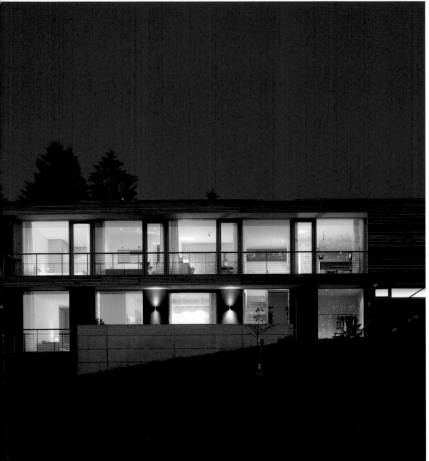

Built perpendicularly to the slope of a hill, this house adapts delicately to the site and relates its different levels to the exterior by means of terraces and balconies.

Dieses Haus wurde schräg an einen Hügel gebaut und passt sich sanft an das Gelände an. Die verschiedenen Ebenen sind über Terrassen und Balkone mit der Umgebung verbunden.

Construite perpendiculairement à la pente d'une colline, cette habitation s'adapte délicatement au terrain, et relie les différents niveaux à l'extérieur par le truchement de terrasses et de balcons.

Construida perpendicularmente a la pendiente de una colina, esta vivienda se adapta delicadamente al terreno y relaciona los distintos niveles con el exterior a través de terrazas y balcones.

Costruita perpendicolarmente al pendio di una collina, questa abitazione si adatta delicatamente al terreno, e mette in relazione i diversi livelli con l'esterno mediante terrazzi e balconi.

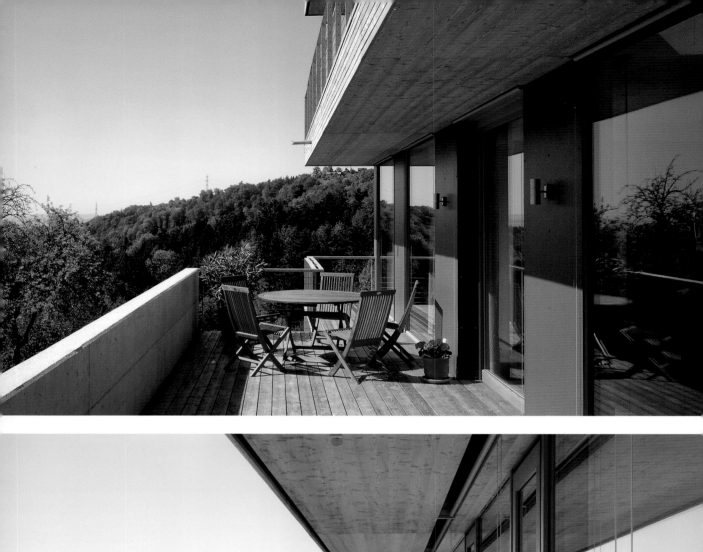
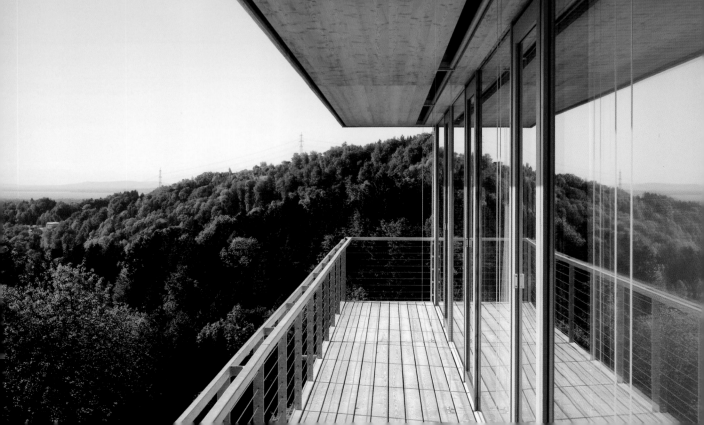

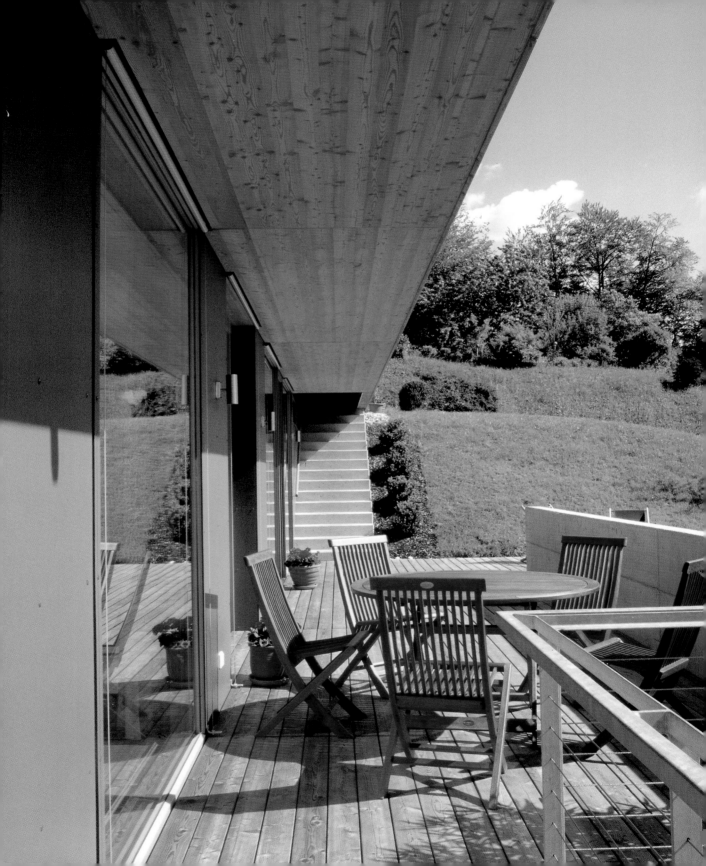

Pictet House

Architect: Charles Pictet

Location: Les Diableret, Vaud, Switzerland

Year: 2004

Photography: Francesca Giovanelli

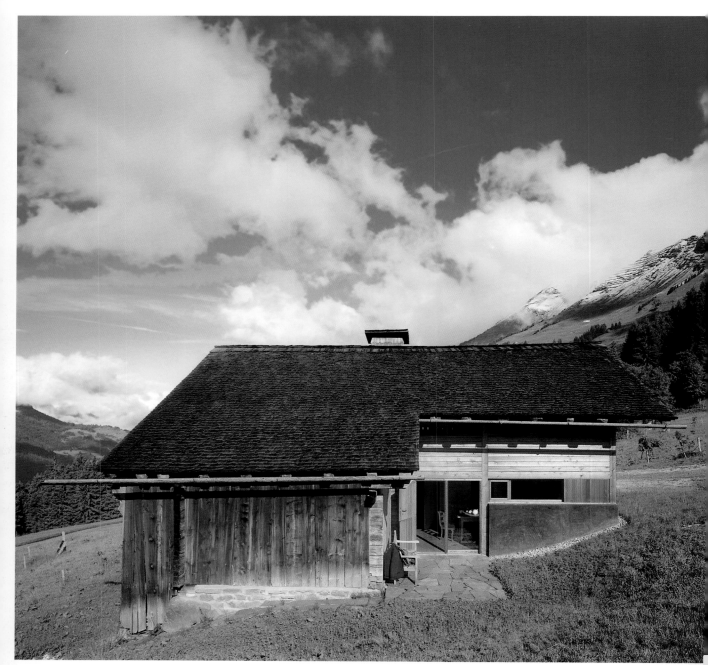

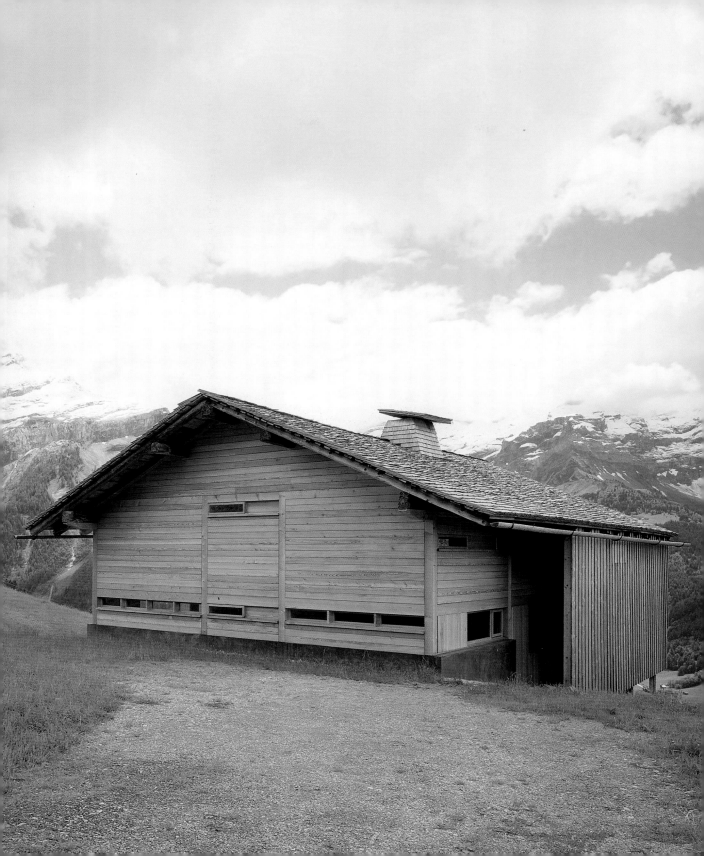

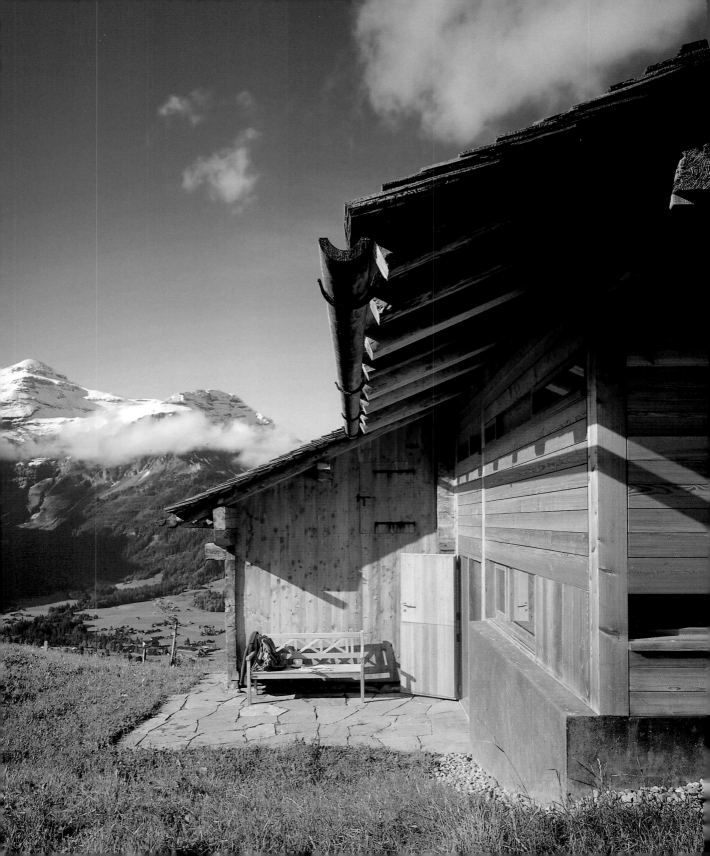

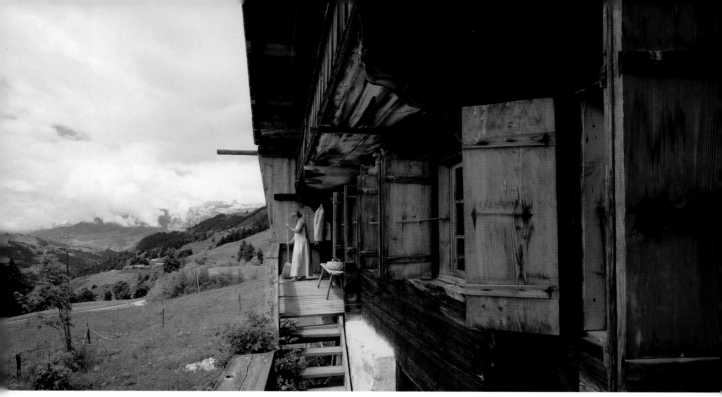

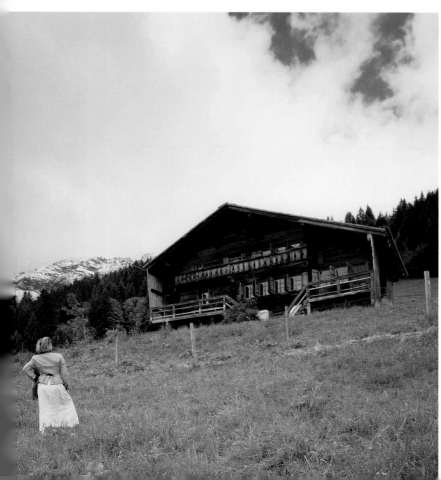

The refurbishment of this 1872 house in the Swiss Alps, restored and extended to embark on a new life, has managed to preserve all the charm and the atmosphere of the original building.

Dieses Wohnhaus in den Schweizer Alpen aus dem Jahr 1872 wurde renoviert und erweitert, wobei es gelang, den Zauber und die Stimmung des Originalgebäudes zu erhalten.

La réhabilitation de cette habitation de 1872, située dans les Alpes suisses, restaurée et agrandie pour une deuxième vie, a su conserver tout le charme et l'ambiance de la construction initiale.

La recuperación de esta vivienda de 1872 situada en los Alpes suizos, restaurada y ampliada para una nueva vida, ha sabido mantener todo el encanto y el ambiente de la construcción original.

Questa abitazione, situata nelle Alpi svizzere e che risale al 1872, è stata recuperata grazie a dei lavori di restauro ed ampliamento che le hanno dato una nuova vita, pur mantenendo tutto il fascino e l'ambiente della costruzione originaria.

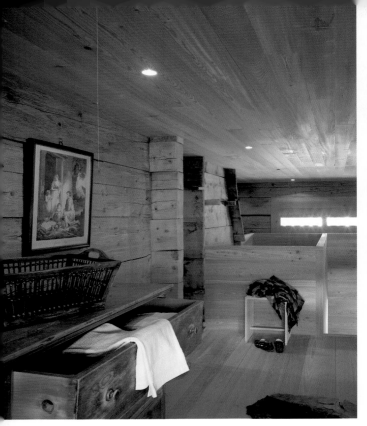

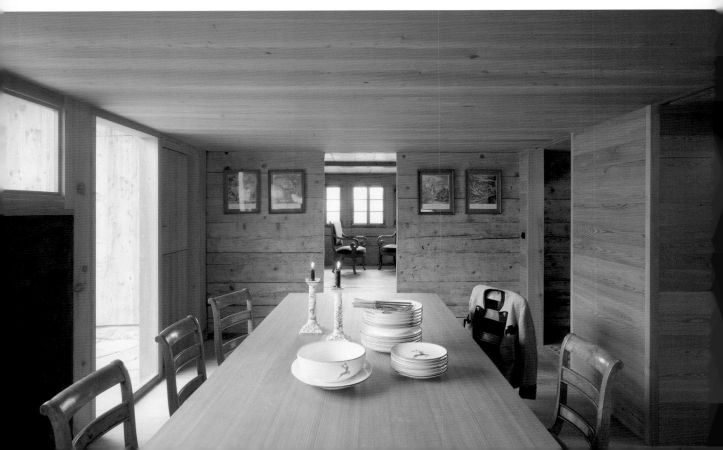

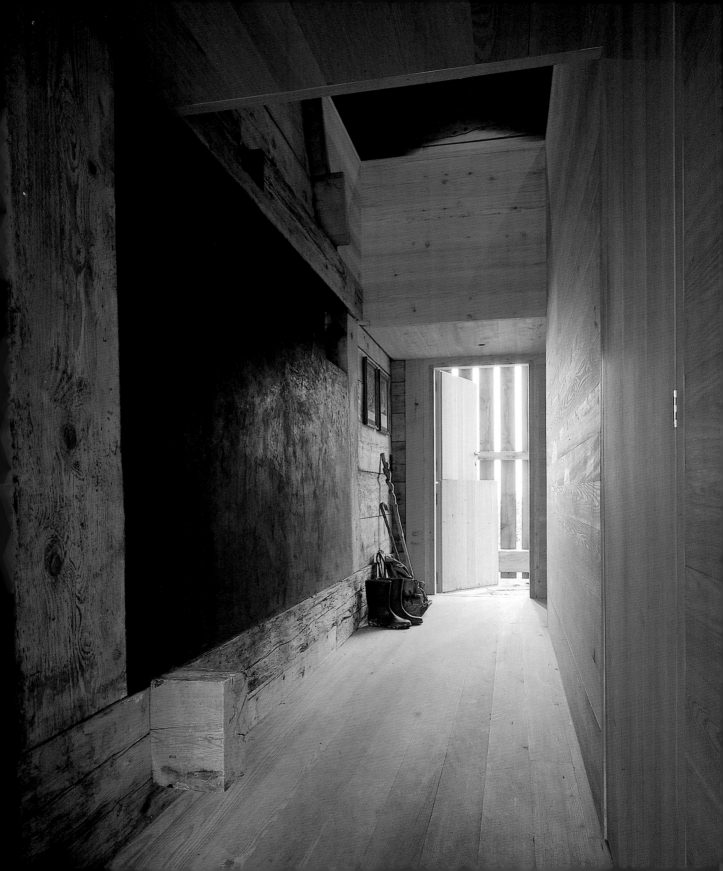

Heavy Structure Houses

Häuser mit schwerer Struktur

Maisons a structure lourde

Casas de estructura pesada

Case dalla struttura pesante

The origins of this construction system go back to the Neolithic era, and it is the result of the natural evolution of the tree-trunk house at a time when raw materials had become scarcer. The main building structure is a wooden framework, conceived initially to support the walls and subsequently as a structure independent of them. It first emerged in Europe and China and later spread to North America, Japan and South-East Asia. As a system it reached its zenith at the end of the Middle Ages and continued to be applied until the nineteenth century, when it fell rapidly into decline. The modern version emerged during the second half of the twentieth century, with the advent of new steel linking systems. It consists of a main structure of sturdy pillars and girders of large timber scantling on which a second order structure rests, constituting the noggings and façade apertures. Though based on modules, these allow for a certain degree of flexibility and even the use of irregular gridirons, which provide designers with greater freedom. Buildings constructed by this system admit the use of other materials, which may either conceal the original structure or leave it bare. However, the need to base the structure on porticoes formed by the main pillars and beams sometimes generates certain rigidity in the distribution.

Die Ursprünge dieser Bauweise gehen auf die Jungsteinzeit zurück. Als das Rohmaterial für die Holzstammhäuser nicht mehr so reichlich vorhanden war, fand eine natürliche Weiterentwicklung statt. Bei dieser Bauweise gibt es ein Skelett aus Holz, anfangs als Gerüst für die Mauern und später als von den Mauern unabhängige Struktur. Diese Bauweise entstand in Europa und China und breitete sich später auch in Nordamerika, Japan und im Südosten Asiens aus. Gegen Ende des Mittelalters erlebte diese Bauweise ihren Höhepunkt, und sie wurde weiterhin bis ins 19. Jh. verwendet, danach jedoch ging die Verwendung dieses Bautyps allmählich zurück. Die moderne Version wurde in der zweiten Hälfte des 20. Jh. entwickelt, als man neue Verbindungssysteme aus Stahl einsetzte. Das System basiert auf einer Hauptstruktur aus Pfeilern und Tragbalken, die große Rahmen bilden, auf die sich eine zweite, untergeordnete Struktur mit der Ausfachung und den Fassadenöffnungen stützt. Dieses modulare System ist sehr flexibel und es können sogar unregelmäßige Raster benutzt werden, so dass man größere Freiheit beim Entwurf hat. Bei Gebäuden, die mit diesem System errichtet wurden, können auch andere Materialien eingesetzt werden, die die Originalstruktur verdecken oder frei lassen. Jedoch ist die Raumaufteilung etwas eingeschränkt, da die Verteilung der Hauptpfeiler und Hauptträger nicht verändert werden kann.

Les origines de cette typologie de construction remontent au néolithique et découlent de l'évolution naturelle de la maison de rondins, à l'époque où cette matière première n'était pas si abondante. La construction démarre à partir d'une ossature de bois qui, au départ, forme l'armature des murs pour devenir ensuite une structure indépendante. Elle apparaît au début en Europe et en Chine et s'étend plus tard à l'Amérique du Nord, au Japon et à l'Asie du sud-est. Elle connaît son apogée à la fin du Moyen Age et se prolonge jusqu'au XIXe siècle, pour décliner rapidement. La version moderne apparaît dans la seconde moitié du XXe siècle, avec les systèmes d'assemblage en acier. Elle est constituée d'une structure principale à base de piliers et de poutres maîtresses à grand équerrage sur laquelle repose une ossature secondaire, pour s'adapter aux hourdis et creux de façade. En plus d'être modulable, cette structure permet une certaine flexibilité et même l'emploi de réticules irréguliers pour une plus grande liberté lors de la conception du projet. Les édifices construits avec ce système permettent d'employer d'autres matériaux, que ce soit en masquant ou en montrant la structure originale. Toutefois, l'obligation de s'appuyer sur des portiques formés de piliers et poutres maîtresses entraîne, parfois, une certaine rigidité de distribution.

Los orígenes de esta tipología constructiva se remontan al neolítico, y es resultado de la evolución natural de la casa de troncos cuando la materia prima ya no era tan abundante. La construcción parte de un esqueleto de madera, al principio como armazón de los muros y después como estructura independiente de éstos. Apareció en Europa y China, y más tarde se extendió a Norteamérica, Japón y el sureste asiático. La época de mayor apogeo llegó a finales de la Edad Media y se prolongó hasta el siglo XIX, cuando empezó a caer rápidamente. Su versión moderna aparece en la segunda mitad del siglo XX, con nuevos sistemas de unión en acero. Consiste en una estructura principal de pilares y jácenas de gran escuadría sobre la que descansa una estructura de segundo orden, para conformar los forjados y los huecos de fachada. A pesar de basarse en la modulación, ésta permite cierta flexibilidad e incluso el empleo de retículas irregulares para poder diseñar con mayor libertad. Los edificios construidos con este sistema admiten otros materiales, ya sea escondiendo o mostrando la estructura original; sin embargo, la necesidad de basarse en pórticos formados con los pilares y vigas principales genera, a veces, cierta rigidez en la distribución.

Questa tipologia costruttiva, le cui origini risalgono al neolitico, è il risultato dell'evoluzione naturale della casa in tronchi quando la materia prima non è più così abbondante. La costruzione parte da uno scheletro in legno, all'inizio come orditura dei muri e dopo come struttura indipendente da questi. Sorto in Europa e Cina, questo sistema costruttivo si diffonde più tardi in Nord America, Giappone e nel sudest asiatico. Il periodo di massimo apogeo si raggiunse alla fine del Medio Evo, e si prolungò fino al XIX secolo, quando ebbe inizio un rapido declino. La versione moderna compare nella seconda metà del XX secolo, con i nuovi sistemi di unione in acciaio. Questa consiste in una struttura principale di pilastri e travi maestre ben squadrati su cui si adagia una struttura di secondo ordine, che forma le solette e i vuoti di facciata. Nonostante si basi sulla modulazione, questa permette una certa flessibilità e persino l'uso di reticoli irregolari per avere maggiore libertà nella fase progettuale. Gli edifici costruiti con questo sistema ammettono l'uso di altri materiali, che nascondono o mettono in mostra la struttura originale; ciò nonostante, la necessità di basarsi su portici formati da pilastri e travi principali genera, a volte, una certa rigidità nella distribuzione.

House in Lliçà

Architect: Nassar Arquitectes SL (Daniel Nassar and Joaquim Ballarín)
Location: Barcelona, Spain
Year: 1998
Photography: Isabel Codina de Pedro

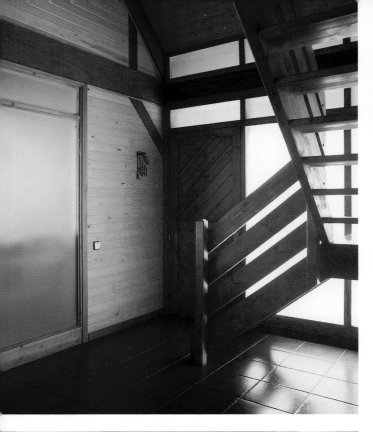
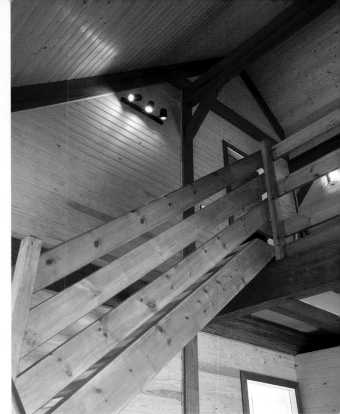

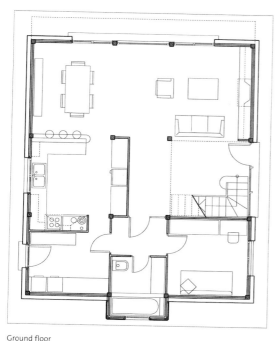

Ground floor

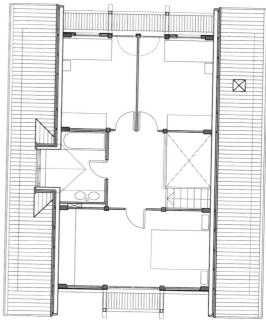

First floor

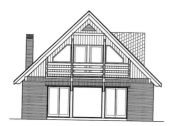

Main façade

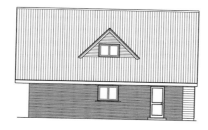

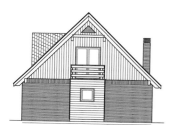

Rear façade

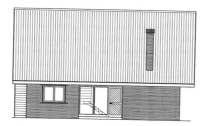

Lateral elevations

The design combines a symmetrical ground floor that is more evident on the floor above. The wood structure provides finishes that meld the house into its surroundings.

Das Erdgeschoss beruht auf einem symmetrischen Schema, das in der oberen Etage noch hervorgehoben wird. Durch die Holzstruktur entstand eine Fassade, die das Haus in seine Umgebung integriert.

Conçue à partir d'un schéma symétrique au rez-de-chaussée qui se fait plus evident à l'étage supérieur, la structure de bois permet des finitions de façade qui intègrent la construction à l'environnement.

Proyectada a partir de un esquema simétrico en planta baja que se hace más evidente en la planta superior, la estructura de madera permite acabados de fachada que integran la construcción con su entorno.

Progettata a partire da uno schema simmetrico a piano terra che si rende più evidente al piano superiore, la struttura in legno consente finiture esterne che integrano l'intera costruzione con l'ambiente che la circonda.

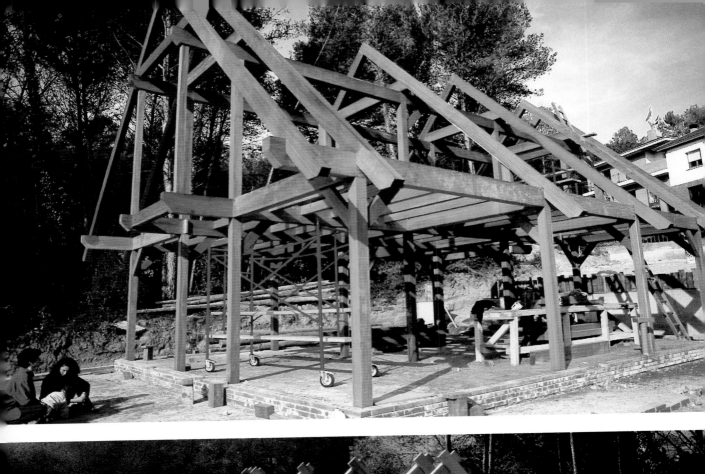
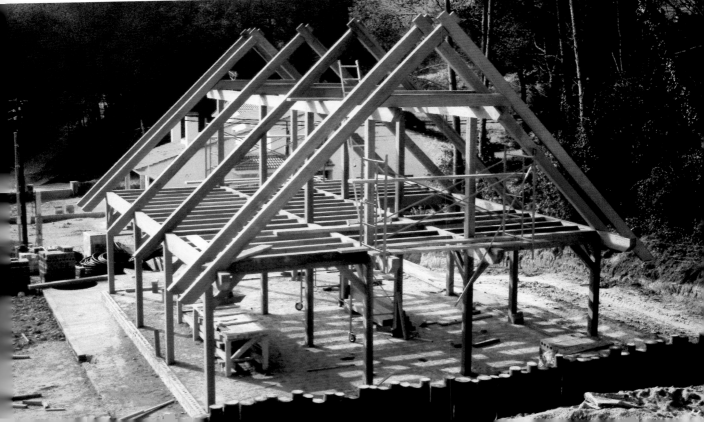

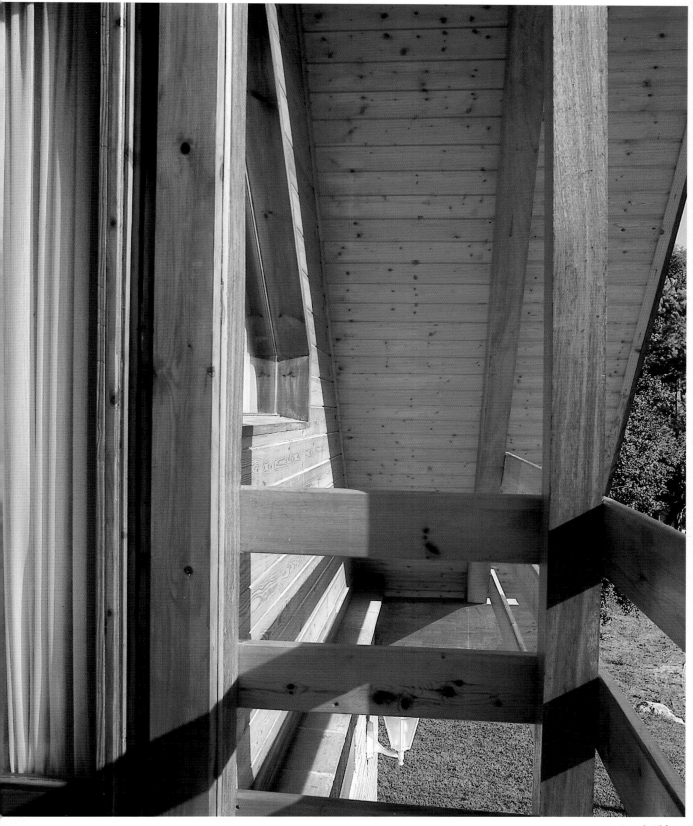

House 22

Architect: Brian MacKay-Lyons Sweetapple Architects Ltd.
Location: Nova Scotia, Canada
Year: 1998
Photography: Undine Pröhl

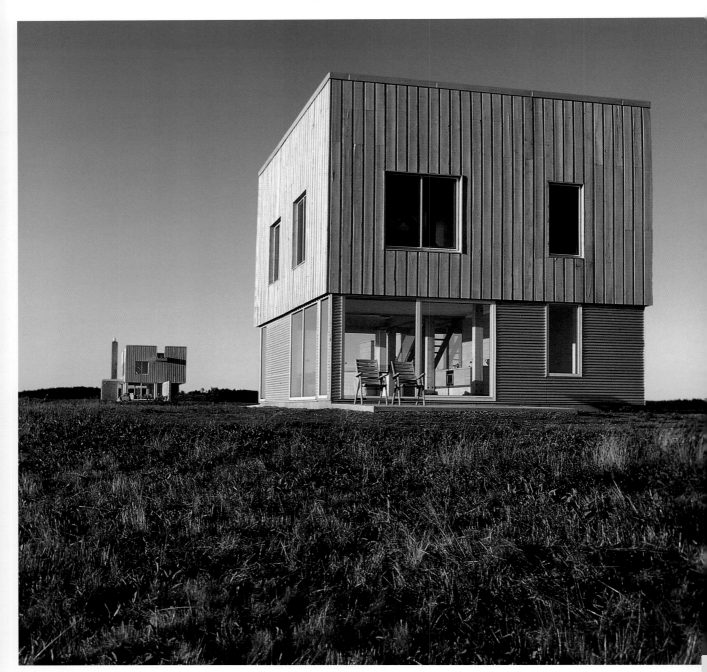

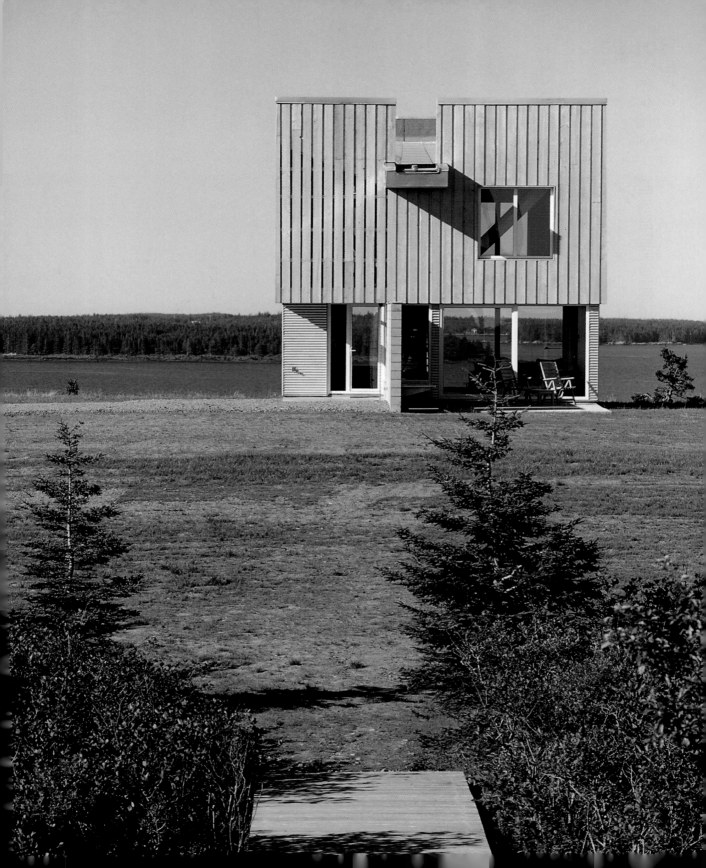

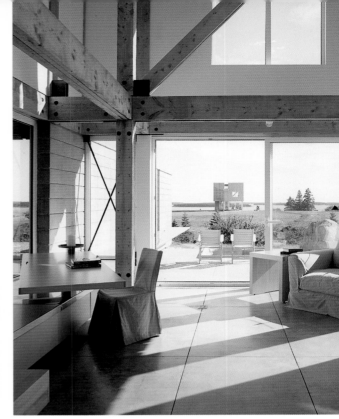
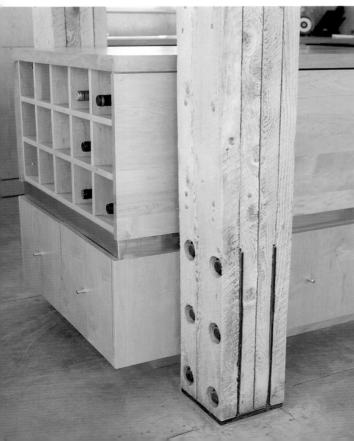
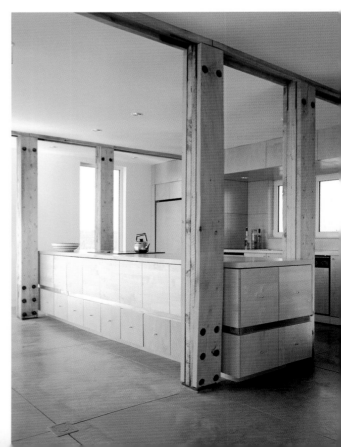

Site plan

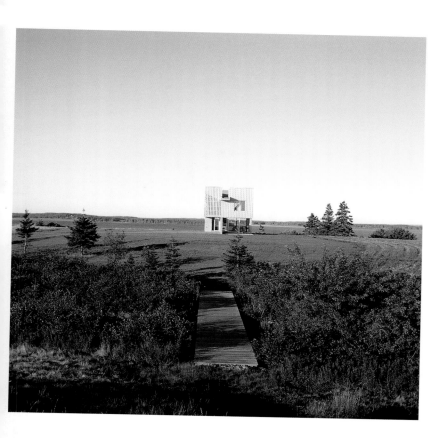

Divided into two parts, related to each other from a certain distance, and standing beside the sea, this house is characterized by transparent, luminous spaces that make no attempt to conceal the wood structure.

Dieses Haus am Meer ist in zwei Teile unterteilt, die in einer gewissen Distanz zueinander in Beziehung stehen. Die transparent wirkenden und hellen Räume sind klar gestaltet und die Holzstruktur wird unverhüllt gezeigt.

Séparée en deux parties, reliées à distance, et située à côté de la mer, cette habitation offre des espaces nets qui font clairement ressortir la structure de bois, tout en transparence et luminosité.

Separada en dos partes relacionadas en la distancia y situada junto al mar, esta vivienda propone espacios netos que muestran una estructura de madera sin tapujos, llenos de transparencias y luminosidad.

Questa abitazione, situata accanto al mare, è divisa in due parti che dialogano a una certa distanza, e propone spazi ben delineati pieni di trasparenze e luminosità che mostrano la struttura in legno senza alcun complesso.

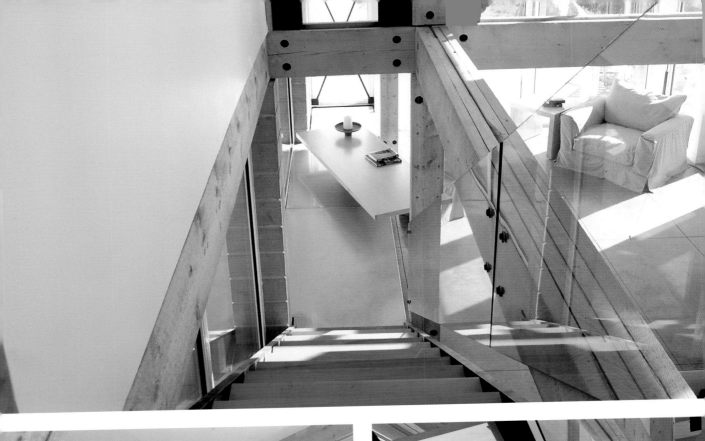
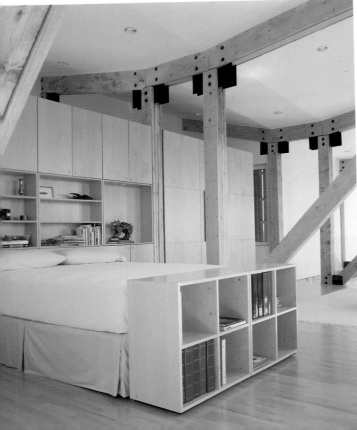
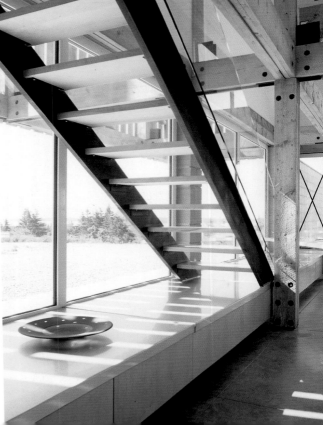

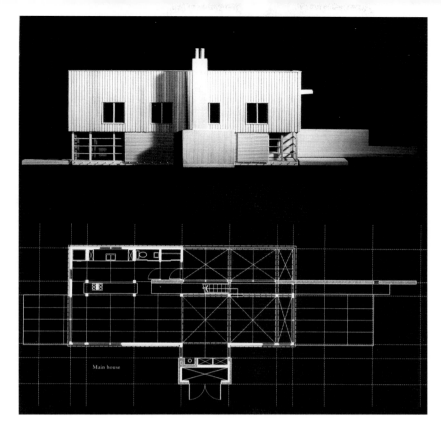

Main house

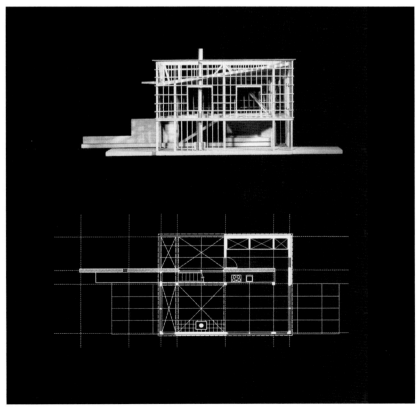

Künzler House

Architect: Johannes Kaufmann Architektur
Location: Bizau, Austria
Year: 2000
Photography: Ignacio Martínez

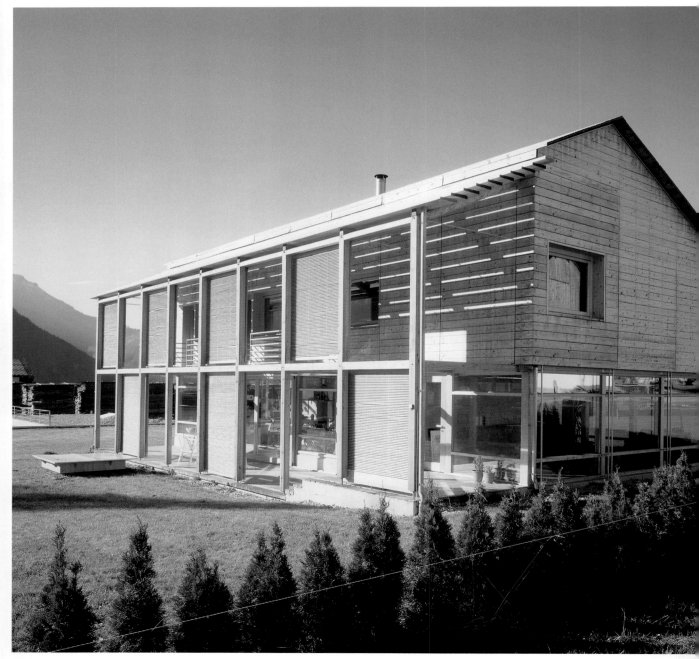

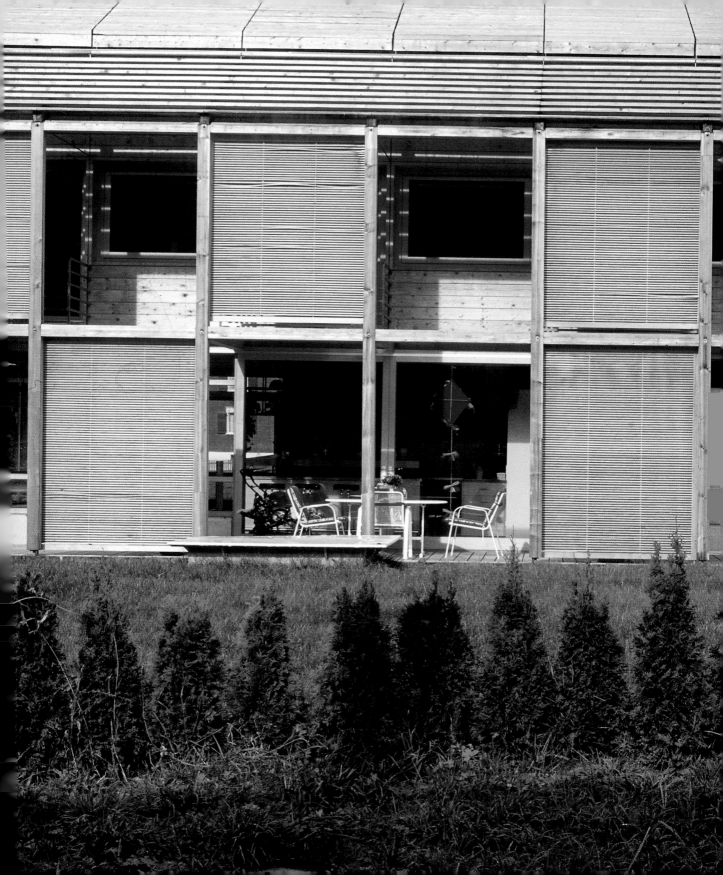

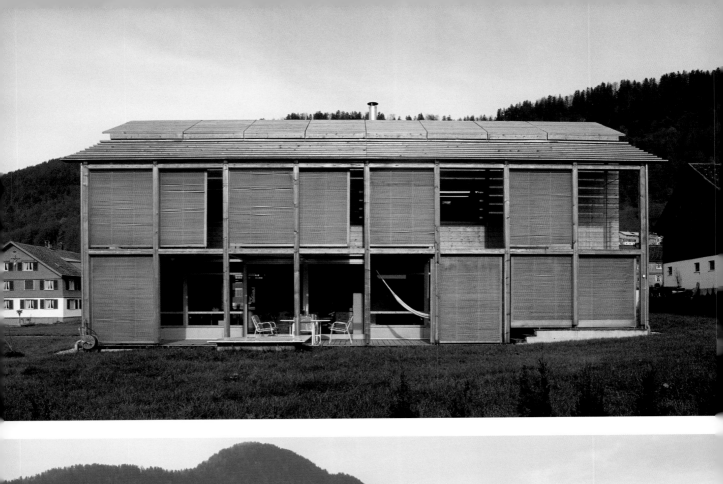
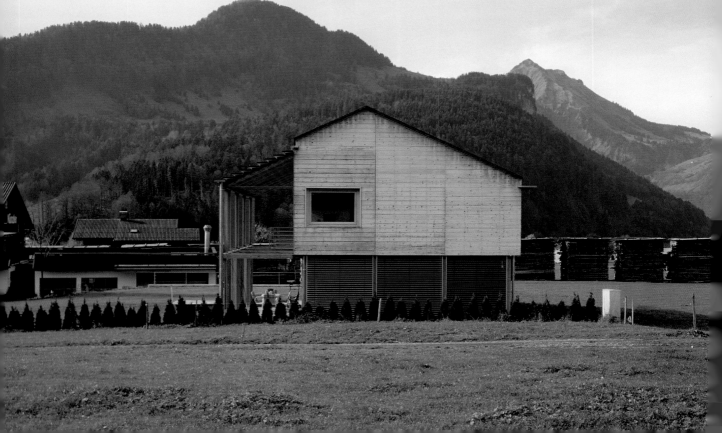

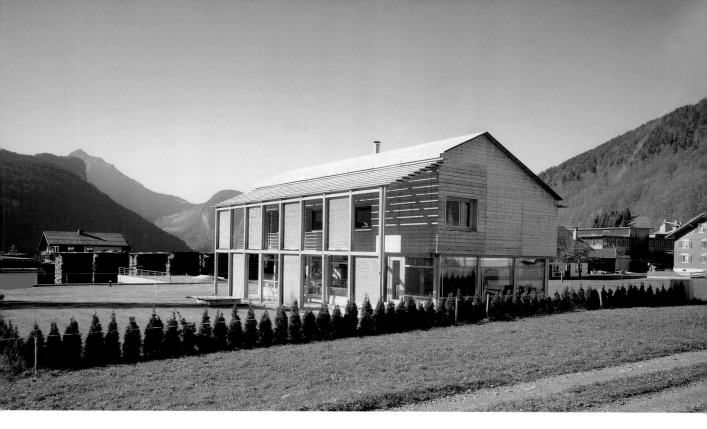

This apparently traditional design, with its highly transparent ground floor, features a south façade that filters sunlight through a terrace protected by movable wooden slats.

Die Formen dieses Gebäudes wirken zunächst traditionell, das Erdgeschoss ist offen und transparent. Durch die Südfassade fällt Sonnenlicht über eine Terrasse ein, die mit beweglichen Holzlamellen geschützt werden kann.

Une volumétrie en principe traditionnelle, dotée d'un rez-de-chaussée très transparent, propose une façade sud qui filtre le rayonnement solaire grâce à une terrasse protégée par des lattes de bois amovibles.

Una volumetría aparentemente tradicional, con una planta baja muy transparente, muestra una fachada sur que filtra radiación solar a través de una terraza protegida con lamas de madera móviles.

Una volumetria a prima vista tradizionale, con un piano terra molto trasparente, propone una facciata sud che fa filtrare i raggi solari attraverso una terrazza protetta con lamine di legno mobili.

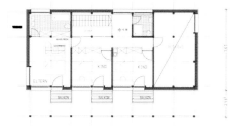

Sections

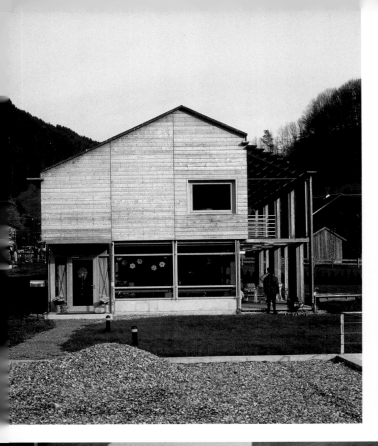
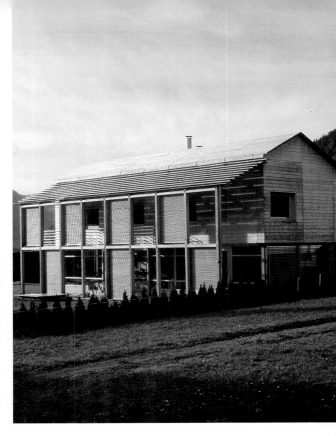
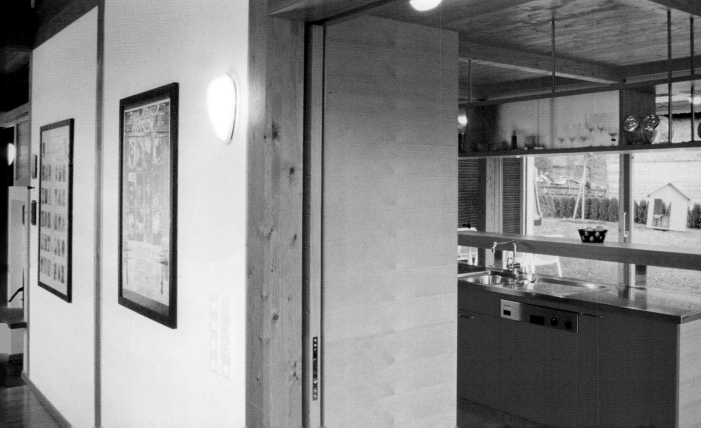

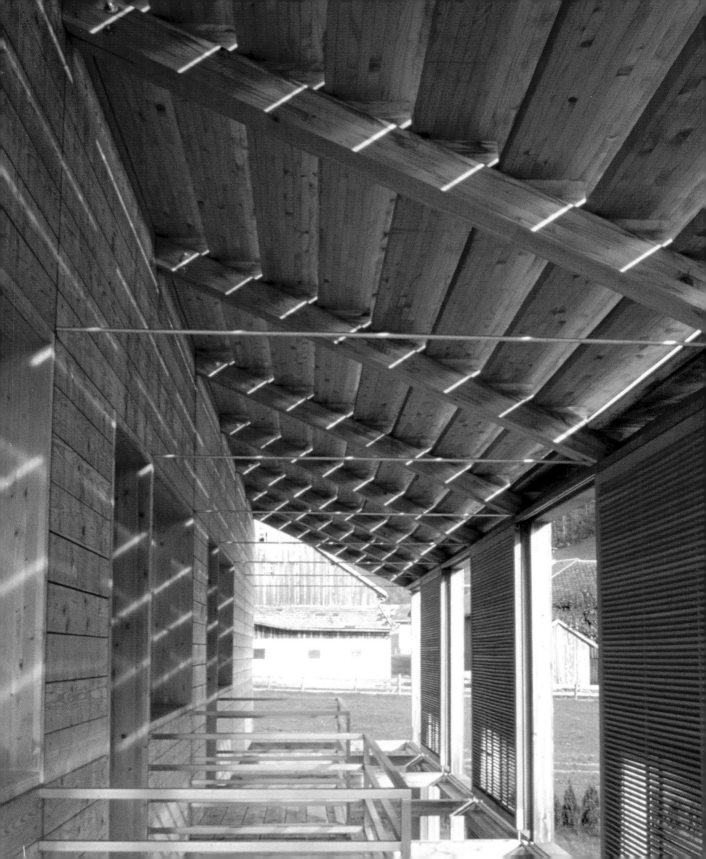

Ridge House

Architect: Olson Sundberg Kundig Allen Architects
Location: Washington, USA
Year: 2003
Photography: Paul Warchol

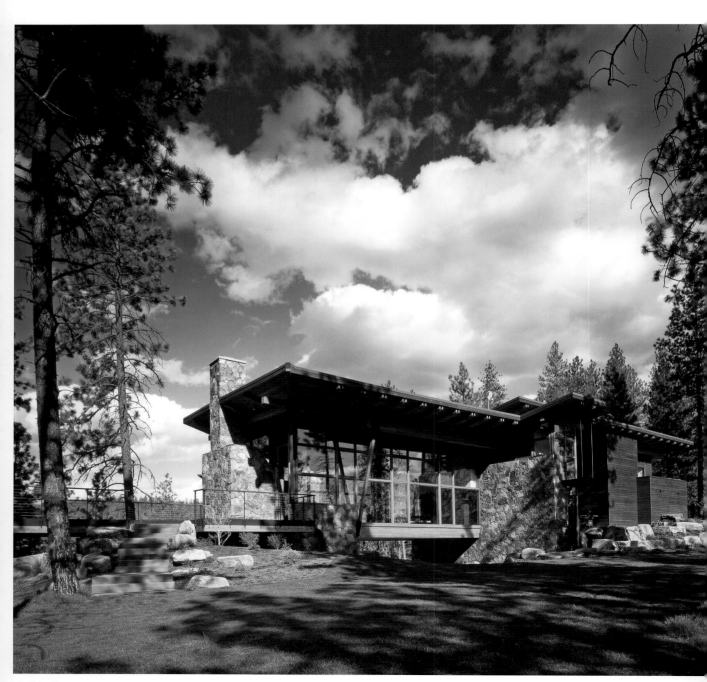

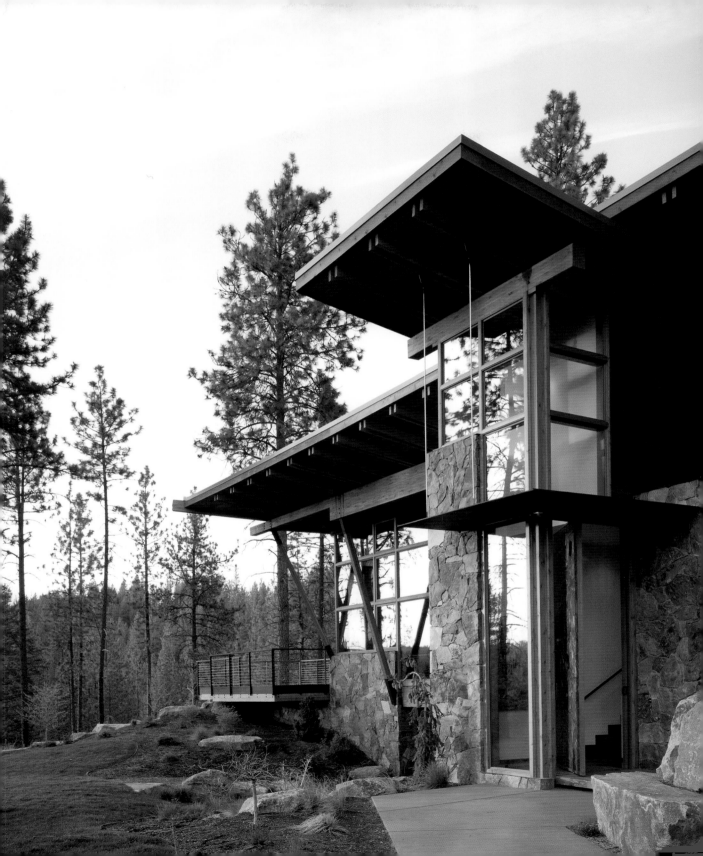

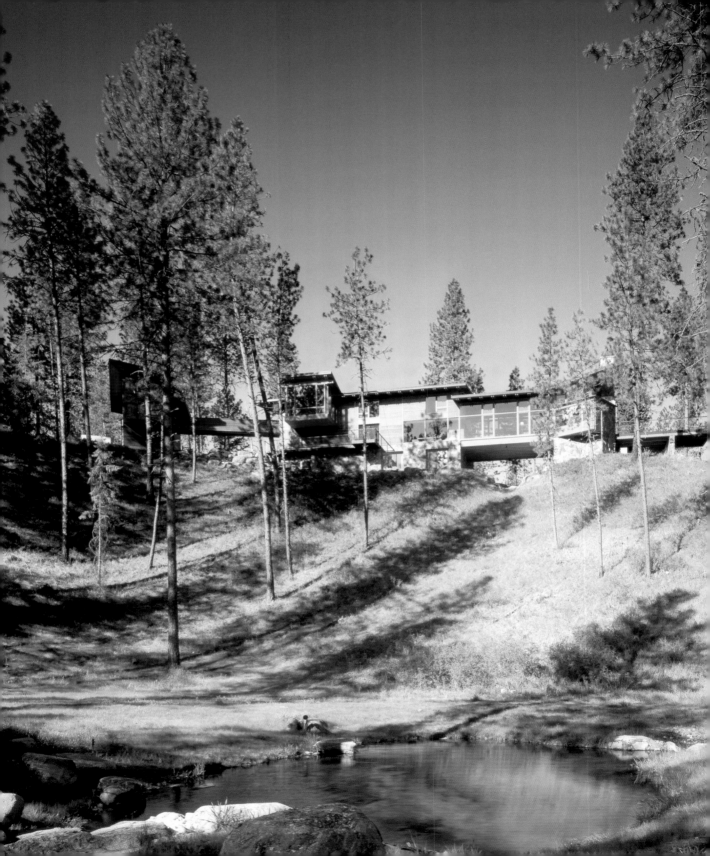

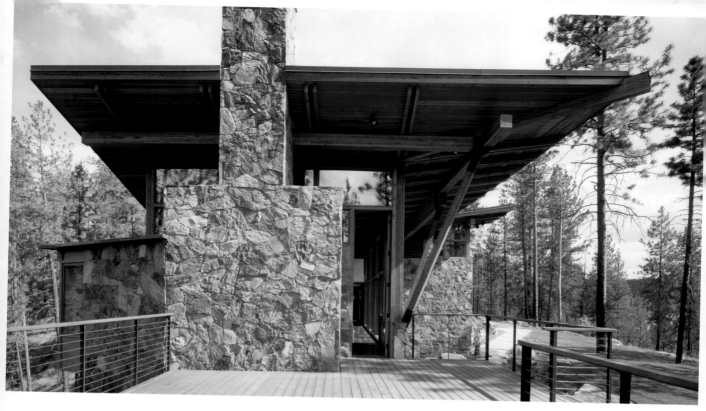

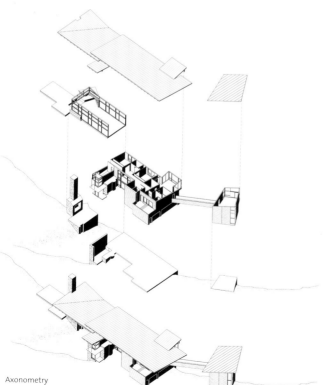

Axonometry

Built on the crest of a hill, this house consists of separate though interrelated volumes placed on mounds. The elevated building as a whole harmonizes with its surroundings.

Dieses Haus steht auf einer Anhöhe und besteht aus mehreren, auf verschiedenen Hügeln gelegenen getrennten Formen, die miteinander in Verbindung gebracht werden. Das erhöhte Gebäude fügt sich perfekt in seine Umgebung ein.

Construite sur la crête d'une colline, cette maison place sur plusieurs monticules des volumes séparés qu'elle relie ensuite, et élève l'édifice tout en l'intégrant à l'environnement.

Construida sobre la cresta de una colina, esta casa coloca sobre diversos montículos volúmenes separados, que relaciona luego, y eleva la edificación a la vez que la relaciona con su entorno.

Questa casa, costruita sulla cresta di una collina, colloca su diversi monticelli volumi separati messi successivamente in relazione tra loro; dall'alto della sua ubicazione, l'edificio si integra nel paesaggio circostante, e vi si fonde.

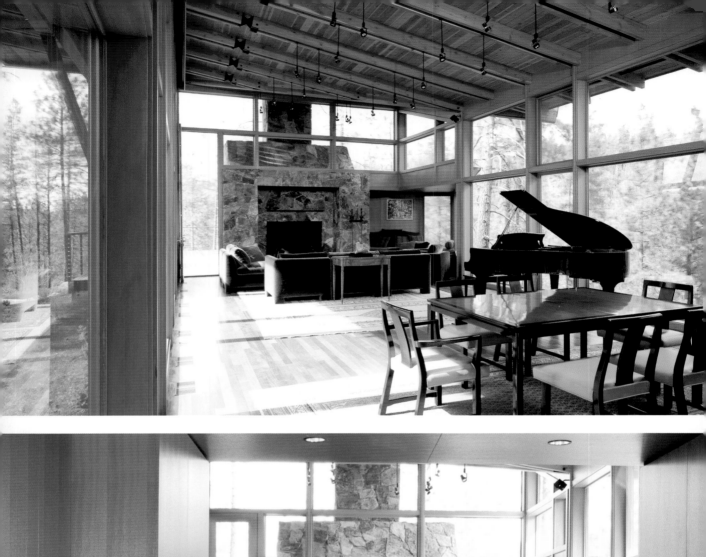
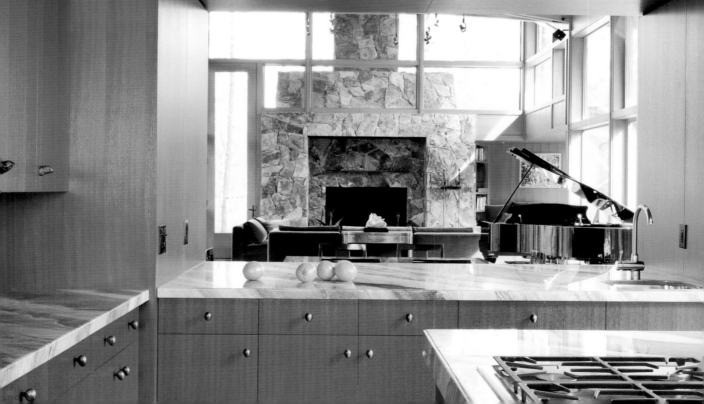

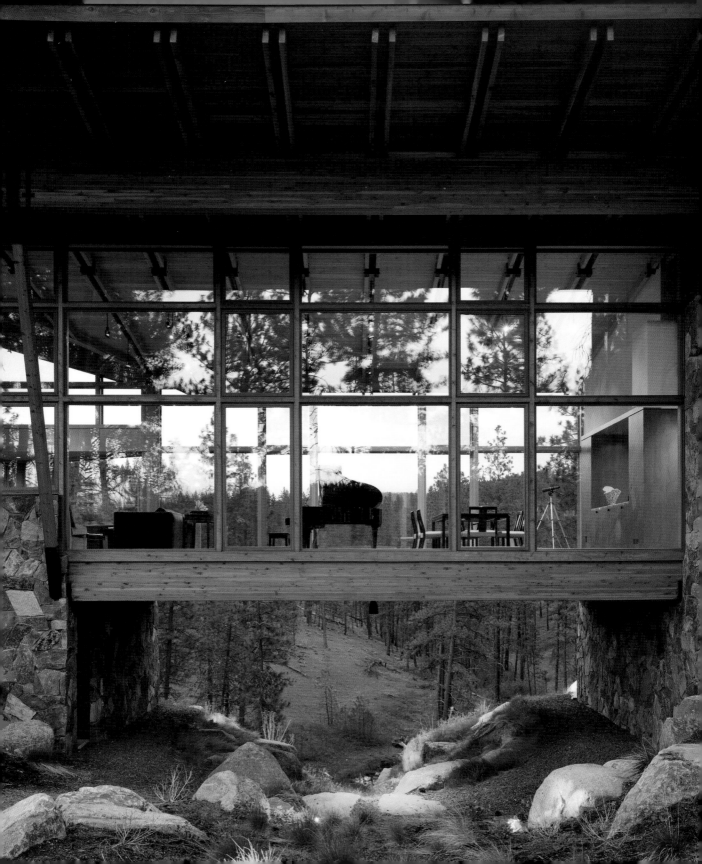

Lang-Kröll House

Architect: Florian Nagler Architekten
Location: Gleißenberg, Germany
Year: 2001
Photography: Stefan Müller Naumann

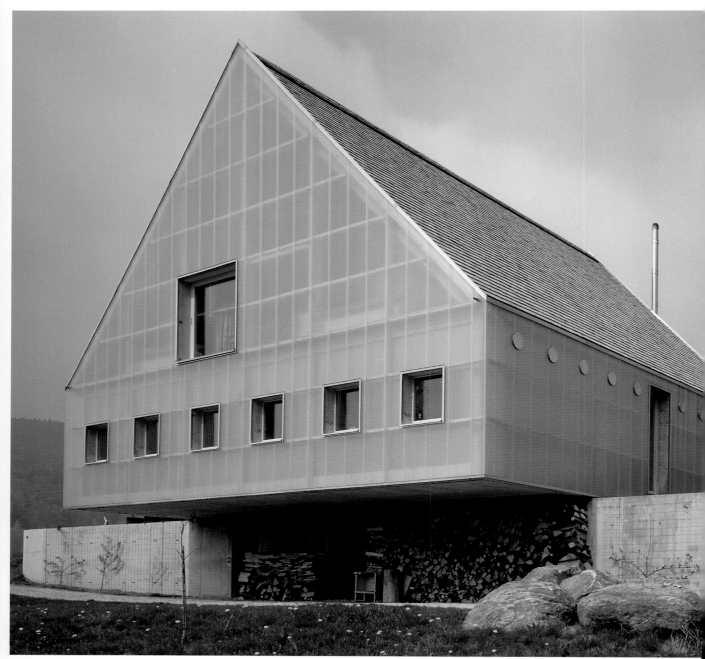

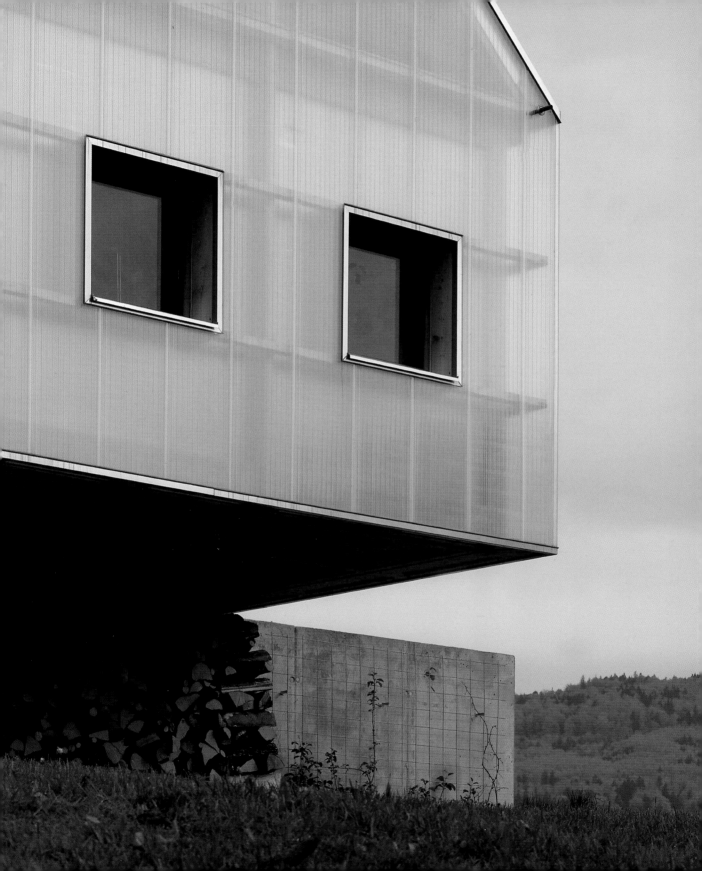

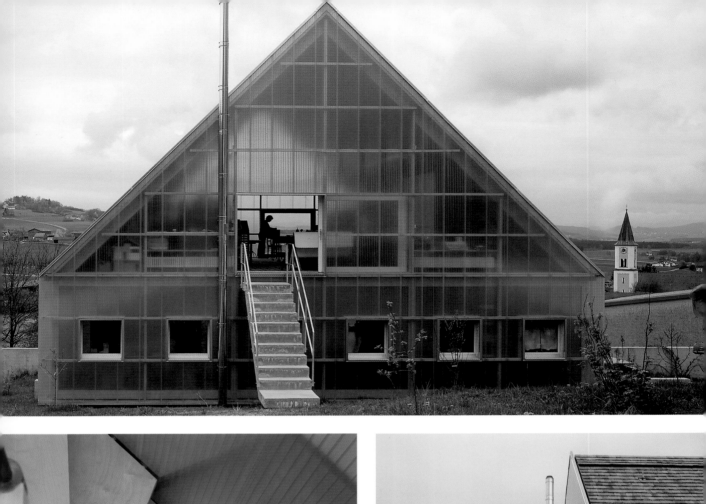
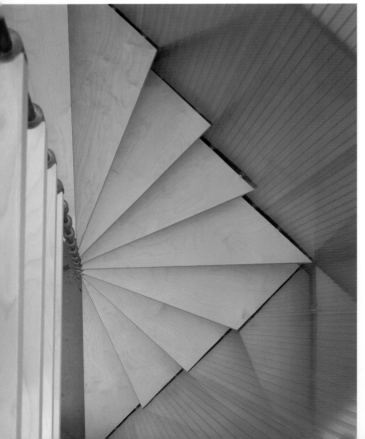
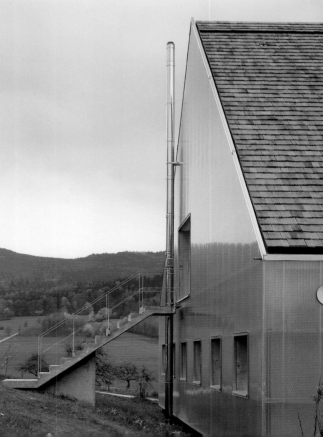

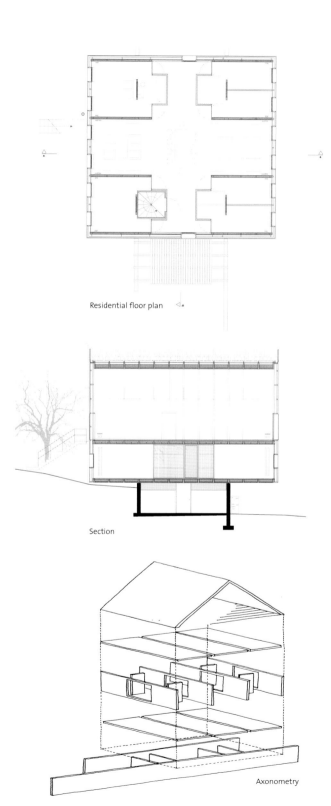

Residential floor plan

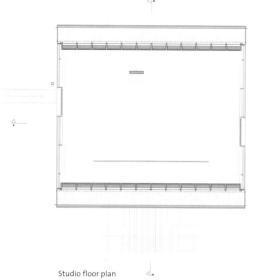

Studio floor plan

Section

Axonometry

A wooden structure, completely covered by a double coating of polycarbonate, insulates the interior from the temperature outside, while allowing light to penetrate, and gives shape to this house with workshop.

Dieses Haus mit Werkstatt besteht aus einer Holzstruktur, die völlig mit einer doppelten Schicht Polykarbonat belegt ist. Dieses Material dient der Wärme- und Kälteisolierung, ist aber gleichzeitig transparent.

Une structure de bois, entièrement couverte par une double couche de poly carbonate, isole de la température extérieure, tout en préservant la transparence, pour donner forme à cette maison dotée d'un atelier.

Una estructura de madera, cubierta completamente por una doble capa de policarbonato, aisla de la temperatura exterior, permitiendo la transparencia, y da forma a esta casa con taller.

Una struttura in legno, coperta interamente da un doppio strato di policarbonato, isola dalla temperatura esterna, conferendo però una certa trasparenza a questa casa atelier.

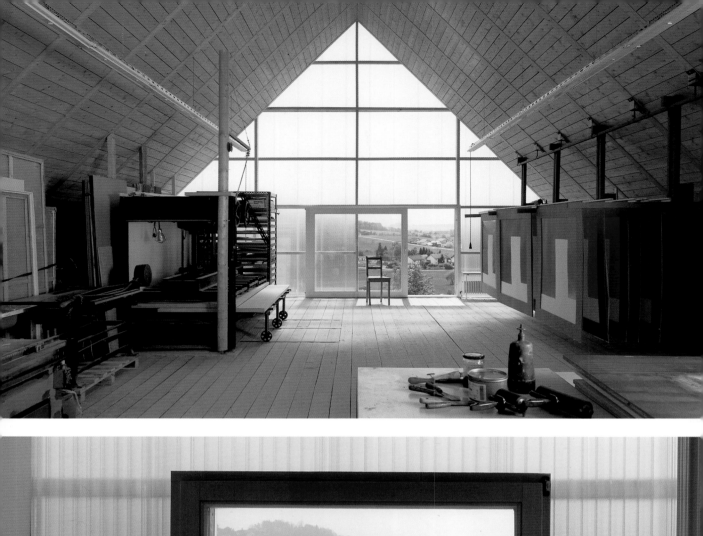

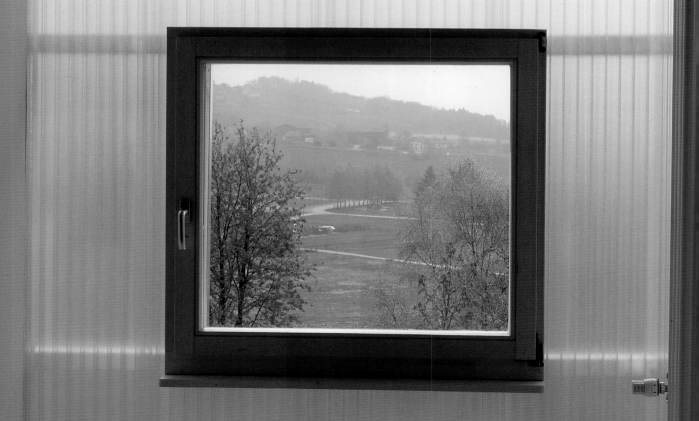

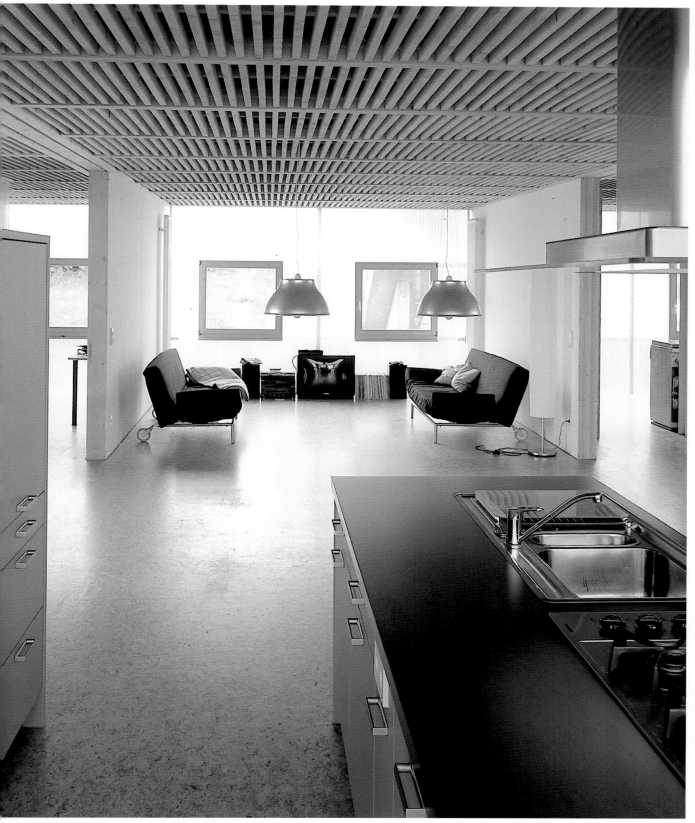

Light Structure Houses
Häuser mit leichter Struktur
Maisons a structure légère
Casas de estructura ligera
Case dalla struttura leggera

The heavy framework evolved toward this new system in the United States during the nineteenth century, at a time when wood was not only in short supply but also lacked the suitable dimensions. The system responds to a new concept, since it makes no distinction between bearing and closing elements. It functions as a spatial structure, consisting of bearing planes in the three main directions, built from narrow scantled timbers. Though this modular system is standardized, it is very flexible and may be subjected to high degrees of specialization. The two most widely used types today are the balloon and the platform. They closely resemble each other, the difference being that in the former case the outside vertical girders are constructed along the entire height of the building whereas in the latter they are built at each story level with floor-ceiling structures between floors, thereby making the building process simpler. The end result is a step forward in the natural evolution of wood houses. It offers flexible, industrialized, prefabricated products that are versatile and allow for a wider range of finishes. This marks a breakaway from the rigid characteristic of older systems and increases the scope for creating spaces, as we see in the houses presented in this chapter.

Die Riegelbauweise entwickelte sich in den Vereinigten Staaten im 19. Jh. zu diesem neuen System weiter. In dieser Zeit gab es immer weniger Holz und oft waren die Stämme zu klein. Dieses System basiert auf einem neuen Konzept, bei dem die tragenden und die abschließenden Elemente nicht mehr unterschieden werden. Das gesamte System funktioniert als eine Raumstruktur, die aus tragenden Ebenen in die drei Hauptrichtungen besteht. Diese Ebenen bilden kleine Rahmen. Es handelt sich um ein genormtes und modulares System, das jedoch sehr flexibel ist und bei dem eine starke Spezialisierung möglich ist. Die beiden am häufigsten eingesetzten Konstruktionsformen sind die der Kugel und der Plattform. Beide Bauweisen ähneln sich stark. Bei der ersten werden die Pfosten der Außenwände entlang der gesamten Höhe des Gebäudes angebracht, während sie bei der zweiten nur auf der Höhe jedes Stockwerks eingesetzt werden. Zwischen den Stockwerken werden dann Tragdecken eingezogen, was den Bauprozess stark vereinfacht. Diese Bauweise ist ein weiterer Fortschritt in der Entwicklung der Holzbauweise, denn es wird ein flexibles, industrielles und vorgefertigtes Produkt angeboten, das vielseitig ist und verschiedene Arten von Verkleidungen zulässt. Die alten Systeme der Holzbauweise waren sehr starr, was bei diesem neuen System nicht mehr der Fall ist. Man hat nun mehr Möglichkeiten bei der Raumgestaltung, was die Gebäude, die in diesem Kapitel vorgestellt werden, deutlich zeigen.

La structure de lattis lourd a évolué vers un nouveau système développé aux Etats Unis, au cours du XIXe siècle, à une époque où le bois disponible est rare et ne possède pas les dimensions adéquates. Le système s'inscrit dans un nouveau concept. Il ne fait pas de différence entre éléments de charge et fermetures. Il fonctionne comme une structure spatiale, formée par des plans porteurs dans les trois directions principales, construite à partir de pièces de petits équerrages. C'est un système normalisé et modulable, extrêmement flexible, qui permet une grande richesse de formes et de volumes habitables spécifiques. Les deux types les plus utilisés actuellement sont ceux du dôme et de la plate-forme. Très similaires, ils se différencient par le fait que le premier construit les montants des murs extérieurs sur toute la hauteur de l'édifice, tandis que le second le fait au niveau de chaque étage, introduisant des lattis entre les étages, simplifiant ainsi le processus de construction. Le résultat final affiche un progrès dans l'évolution naturelle des maisons de bois : les produits offerts sont flexibles, industrialisés et préfabriqués. Marqués par la polyvalence, ils permettent une plus grande diversité de finitions. Cette évolution rompt ainsi avec l'idée de rigidité propre aux systèmes plus anciens et augmente les possibilités de création d'espaces, à l'instar de ce que l'on peut observer dans les constructions présentées dans ce chapitre.

El entramado pesado evoluciona hacia este nuevo sistema en Estados Unidos durante el siglo XIX, en una época en que la escasa madera disponible no tiene las dimensiones adecuadas. El sistema responde a un nuevo concepto, ya que no diferencia entre elementos de carga y cerramientos; funciona como una estructura espacial, formada por planos portantes en las tres direcciones principales construidos a base de piezas de pequeña escuadría. Es un sistema normalizado y modulado pero con gran flexibilidad, que puede estar sujeto a niveles de especialización elevados. Los dos tipos más empleados en la actualidad son los de globo y plataforma; ambos son muy parecidos y se diferencian en que el primero construye los montantes de las paredes exteriores en toda la altura del edificio, mientras que el segundo sólo a la altura de cada planta, e introduce forjados entre los pisos, con lo que el proceso de construcción es más sencillo. El resultado final avanza en la evolución natural de las casas de madera; ofrece productos flexibles, industrializados y prefabricados, que a su vez son más versátiles y permiten diversos acabados. Se rompe así con la idea de rigidez propia de los sistemas más antiguos y se aumentan las posibilidades de creación de espacios, tal y como se observa en las edificaciones presentadas en este capítulo.

L'armatura pesante evolve verso questo nuovo sistema negli Stati Uniti durante il XIX secolo, in un periodo in cui lo scarso legno disponibile non presenta tra l'altro le dimensioni adeguate. Il sistema risponde a un nuovo concetto, visto che non fa nessuna distinzione tra elementi di sostegno e tramezzi; funziona come una struttura spaziale, formata da piani portanti nelle tre direzioni principali, costruiti a base di elementi a squadratura ridotta. Si tratta di un sistema normalizzato e modulato ma con una grande flessibilità, che può sottoporsi ad elevati livelli di specializzazione. Le due tipologie più utilizzate attualmente sono le strutture a pallone e a piattaforma; entrambe sono molto simili e si differenziano per il fatto che la prima costruisce i montanti delle pareti esterne su tutta l'altezza dell'edificio, mentre la seconda li costruisce soltanto all'altezza di ogni piano, e inserisce solette tra i piani, semplificando ulteriormente il processo costruttivo. Il risultato finale va nella direzione dell'evoluzione naturale delle case in legno; offre prodotti flessibili, industrializzati e prefabbricati, che a loro volta sono più versatili e permettono finiture di vario tipo. Si supera così l'idea della rigidità propria dei sistemi del passato e aumentano le possibilità di creazione di spazi, così come si osserva negli edifici presentati in questo capitolo.

Luchsinger House

Architects: Max Bosshard & Christoph Luchsinger
Location: Weggis, Switzerland
Year: 2004
Photography: Francesca Giovanelli

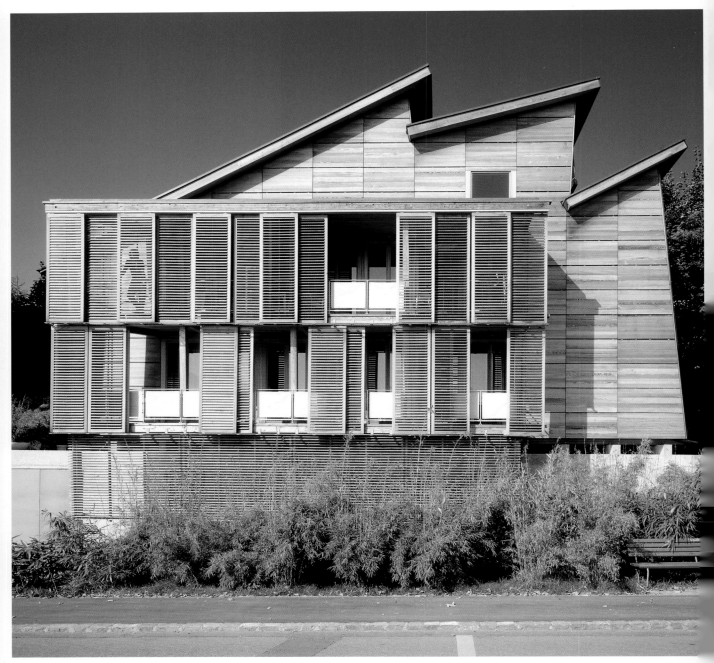

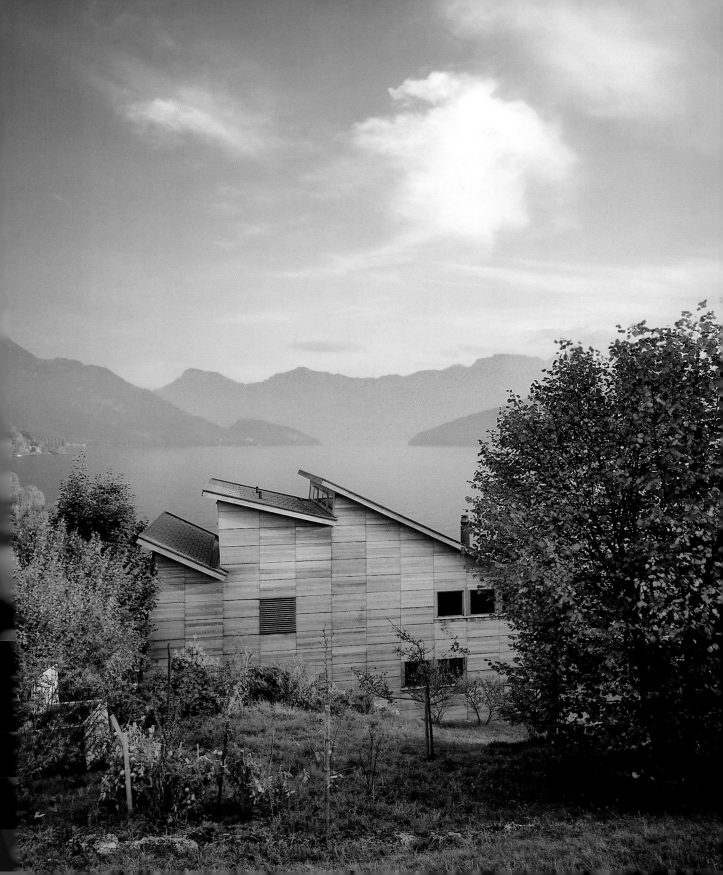

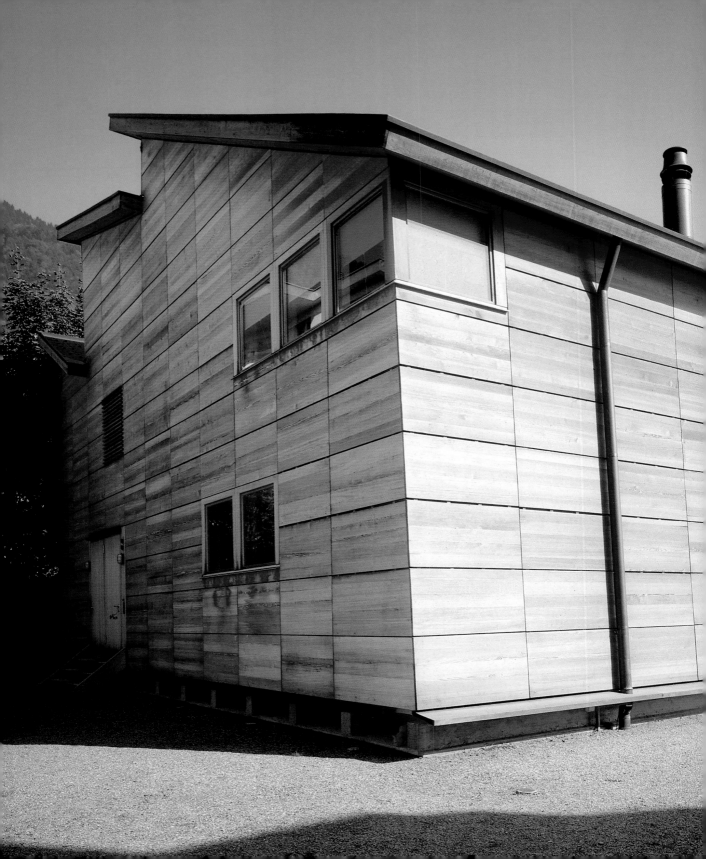

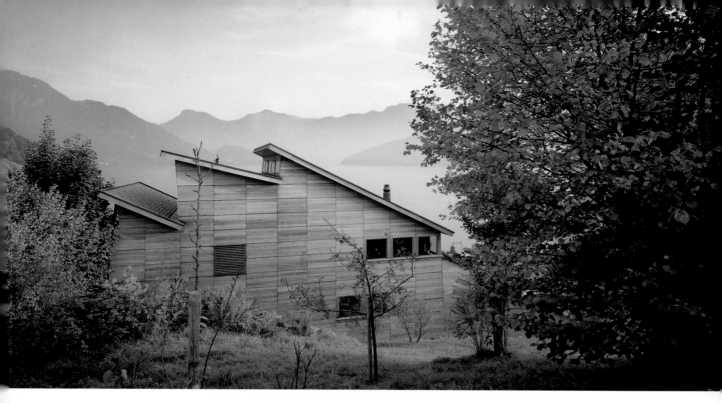

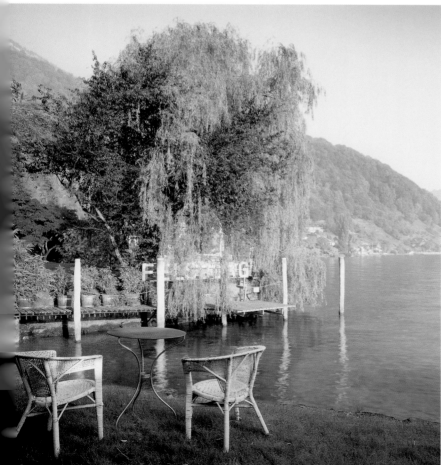

Standing on the shore of a lake, to which it is linked by means of a jetty, this house exploits the expressive potential of wood on its exterior, ranging from slats to more or less closed façades.

Dieses Haus steht am Ufer eines Sees, mit dem es durch einen Steg verbunden ist. Von außen zeigt sich an diesem Gebäude das Material Holz in seiner ganzen Schönheit, sowohl in den Lamellen als auch an den mehr oder weniger geschlossenen Fassaden.

Située sur les rives d'un lac, auquel elle est reliée par un quai, cette résidence utilise les possibilités d'expression du bois à l'extérieur, des lattes jusqu'aux façades plus ou moins fermées.

Situada a orillas de un lago, con el que se relaciona mediante un muelle, esta residencia utiliza las capacidades expresivas de la madera en el exterior, desde láminas hasta fachadas más o menos cerradas.

Situata sulla riva di un lago, con cui comunica mediante una banchina, questa costruzione sfrutta all'esterno le capacità espressive del legno, dalle lamine fino a facciate più o meno chiuse.

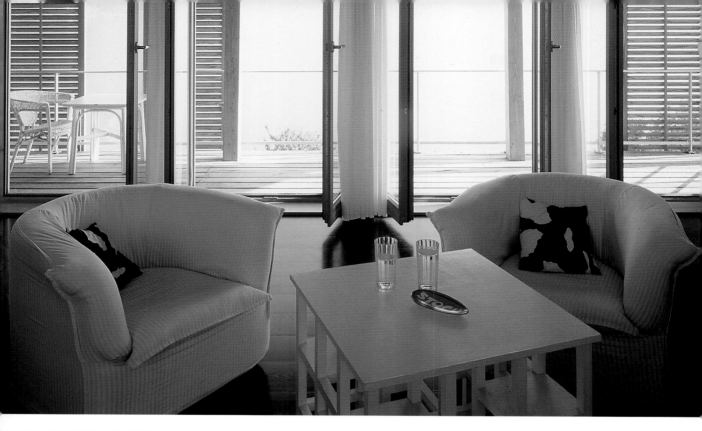

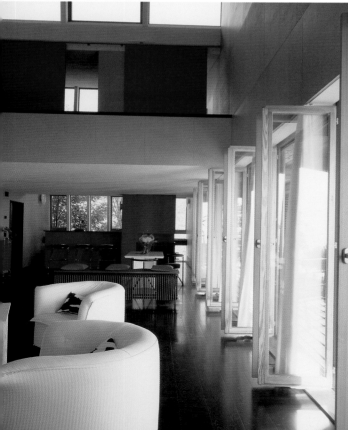

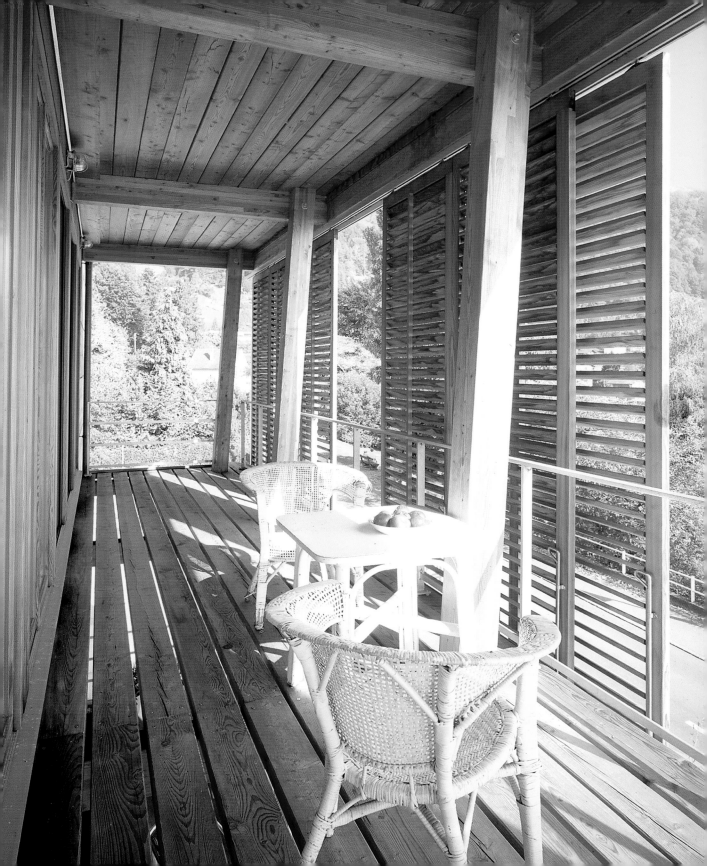

Pavi House

Architect: Johannes Kaufmann Architektur
Location: Bad Waltersdorf, Steiermark, Austria
Year: 2002
Photography: Paul Ott

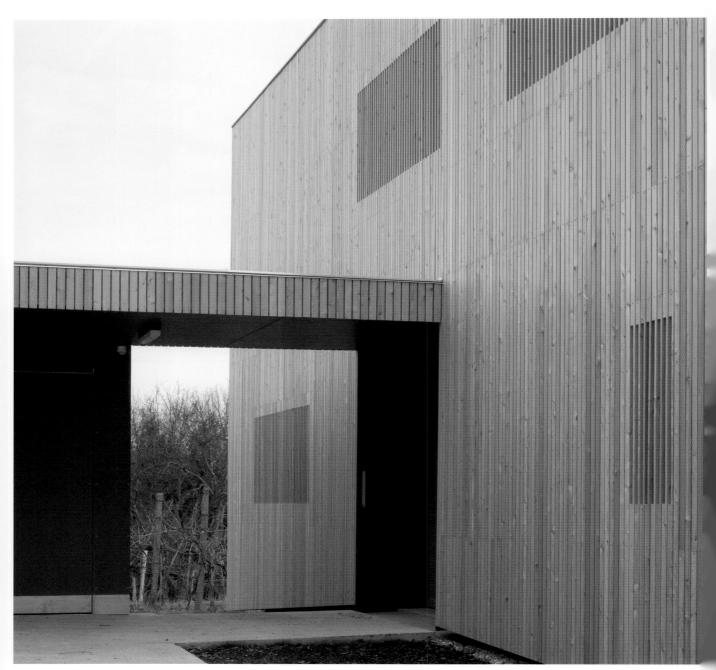

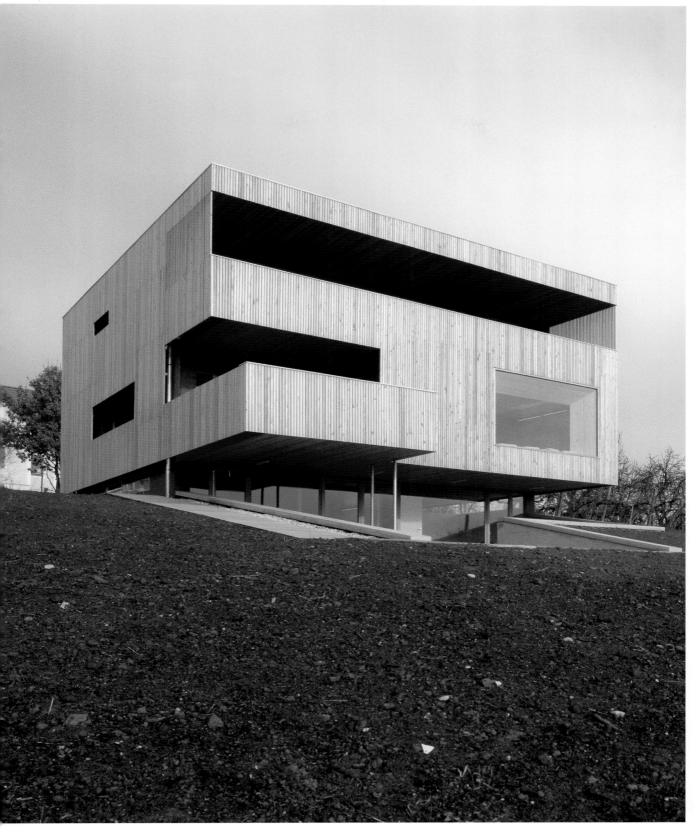

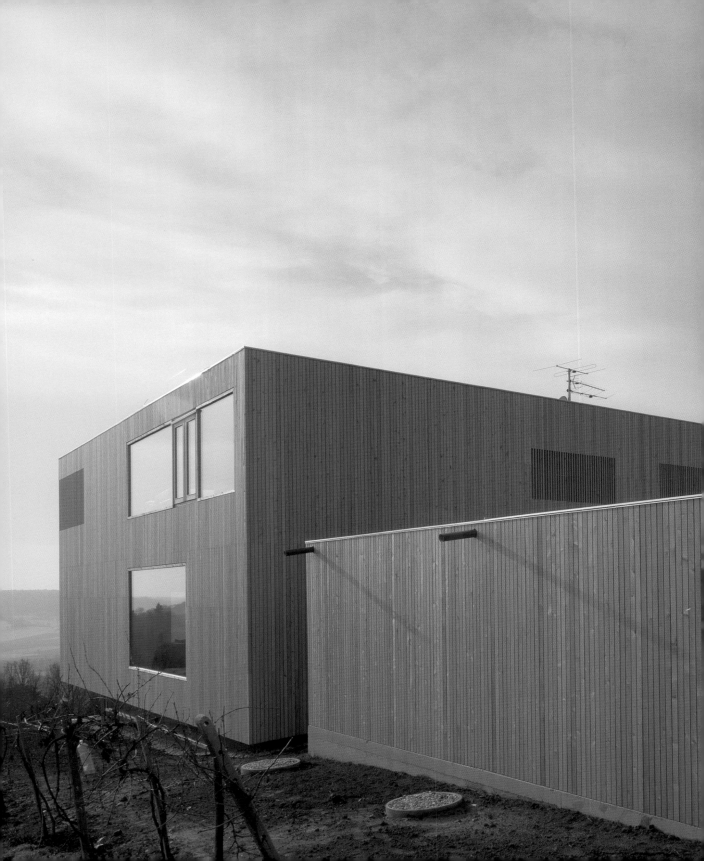

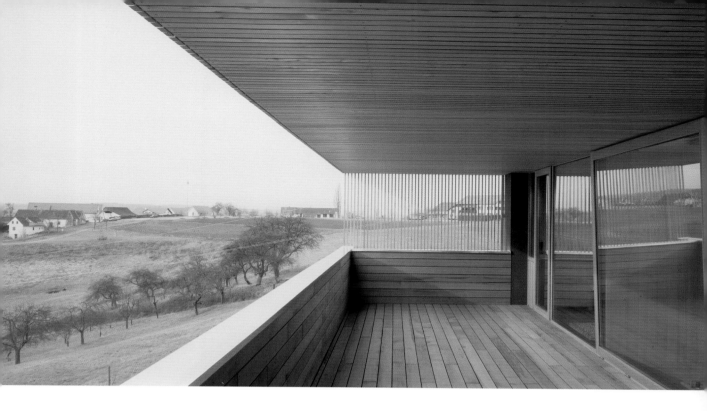

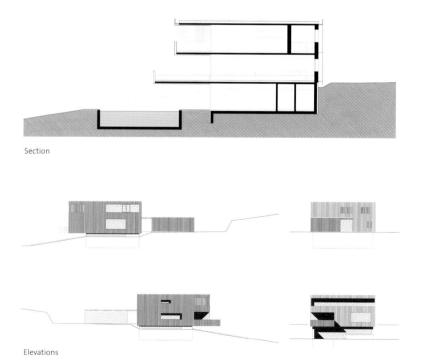

Section

Elevations

Located in a south-facing, gently sloping vine-yard, the north end of this house is half buried while the open south façade is projected weight-lessly toward the landscape.

Dieses Haus steht auf einem Weinberg mit leich-ter Neigung und Südlage. Die Nordseite des Hau-ses ist halb unter der Erde, während die Südfassa-de offen ist und schwerelos über der Landschaft zu schweben scheint.

Située dans un vignoble accusant une légère pente et orientée vers le sud, l'habitation présen-te sa face nord semi-enterrée, alors que la façade sud, ouverte, s'élance tout en légèreté vers le pay-sage.

Situada en un viñedo con una ligera pendiente y orientada hacia el sur, la vivienda presenta su lado norte semienterrado, mientras que la facha-da sur, abierta, se proyecta ingrávida hacia el pai-saje.

Questa abitazione, che sorge in un vigneto con una leggera pendenza, è orientata a sud. Il lato nord è seminterrato, mentre la facciata a sud, aperta, si proietta con leggerezza verso il paesag-gio circostante.

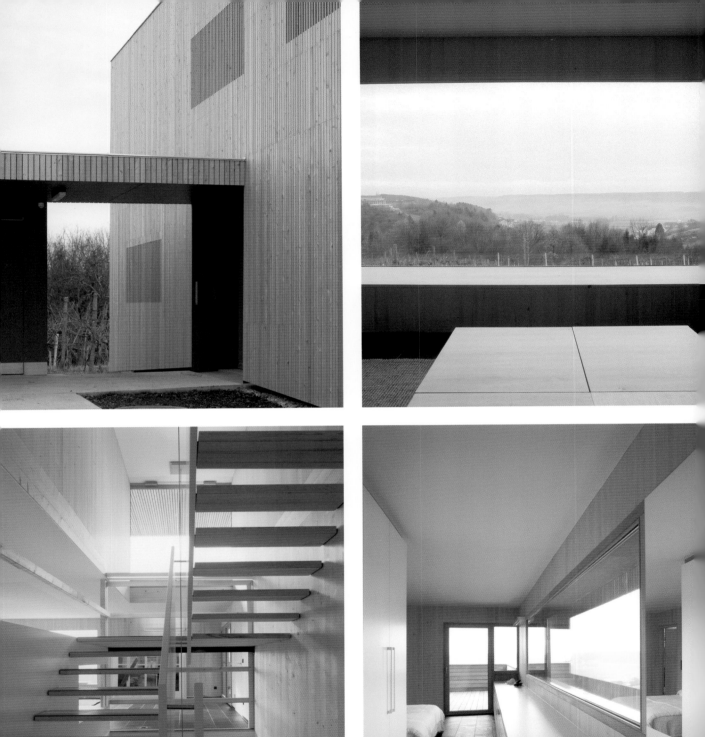

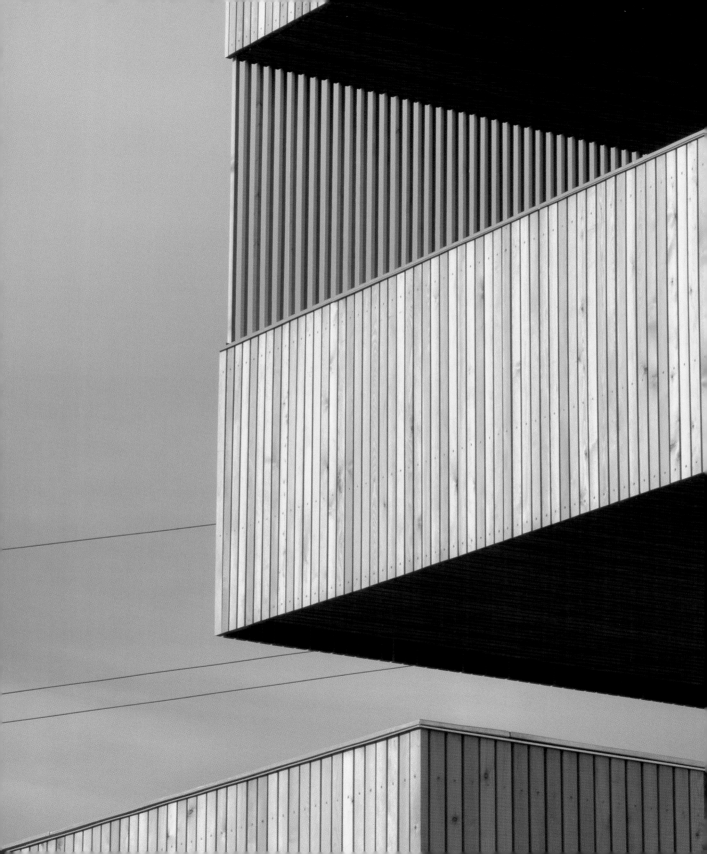

Leschi Residence

Architect: Eric Cobb/E. Cobb Architects Inc.
Collaborators: Emily Li, Ian Butcher, Kirsten Mercer-Cobb, Randal Larsen
Location: Seattle, Washington, USA
Year: 2002
Photography: Paul Warchol

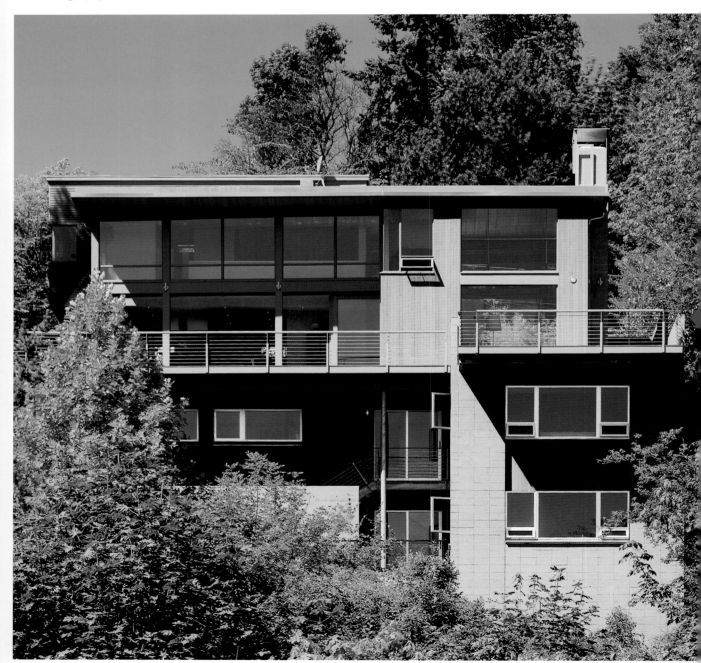

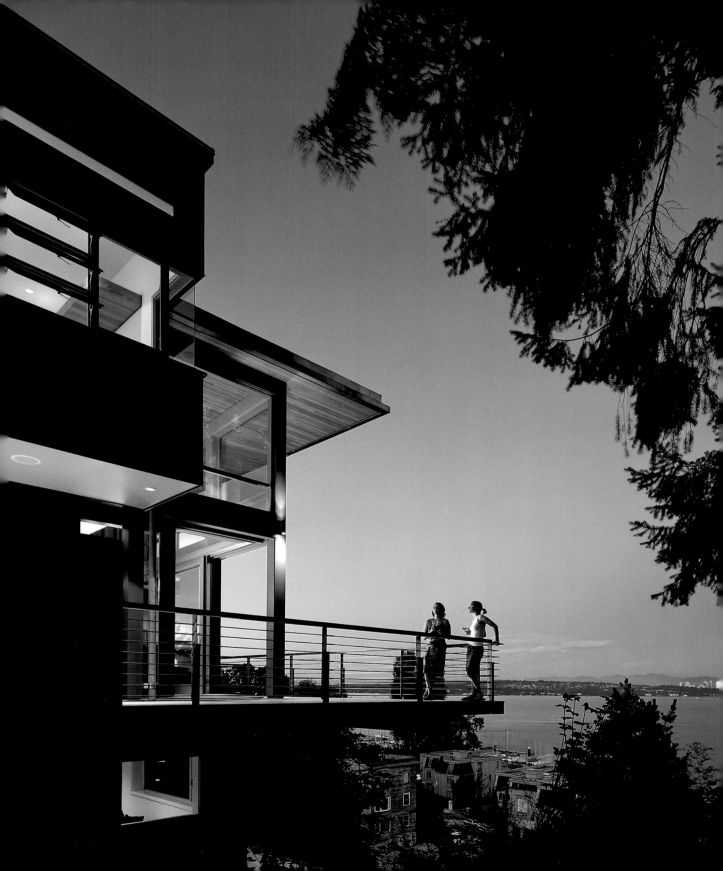

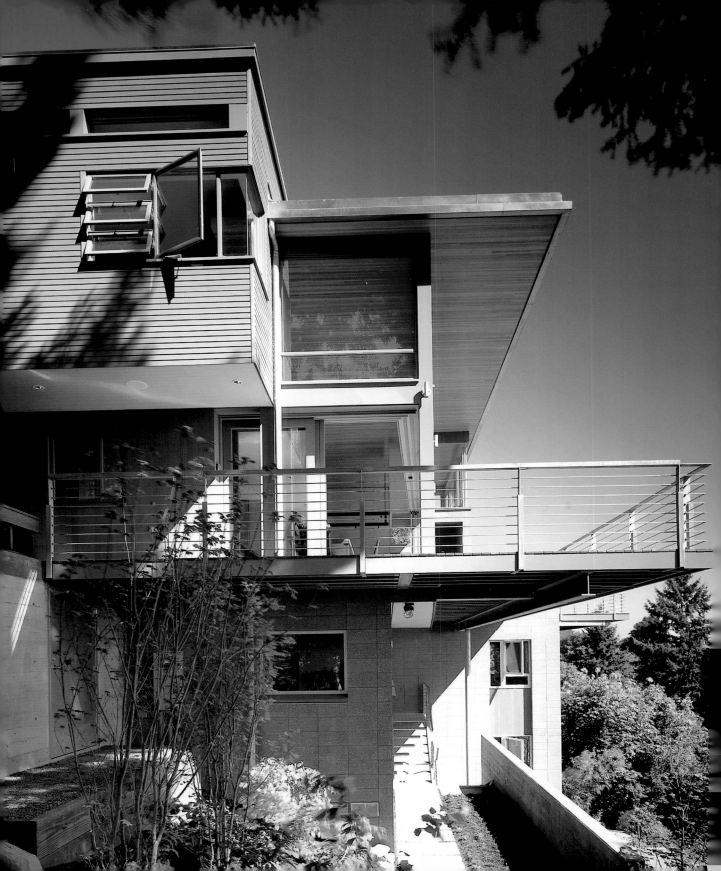

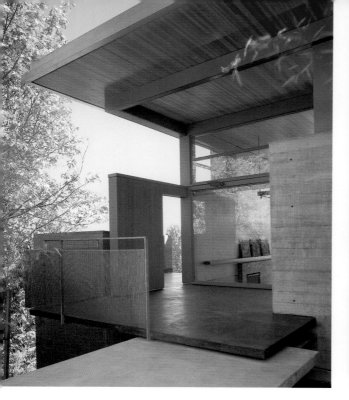

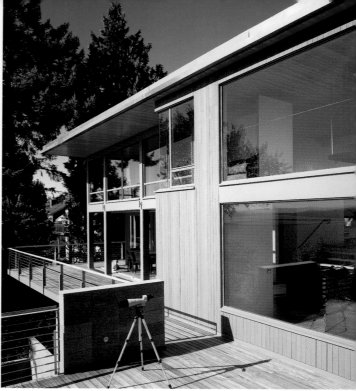

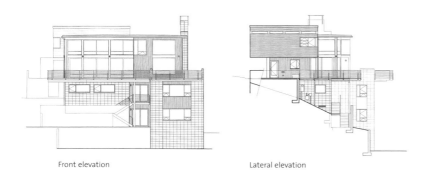

Front elevation

Lateral elevation

Section

Perched on a cliff top, all the living areas of this house are projected in the form of terraces and balconies toward the landscape. The rear façade is protected and the building adapts to the site by means of a combination of solid wall faces and wood.

Dieses Haus steht an einer Steilküste und alle gemeinschaftlich genutzten Räume sind über Terrassen und Balkone mit der Landschaft verbunden. Die hintere Fassade ist geschützt und passt sich dem Gelände an, hier wurden massive Wände mit Holz kombiniert.

Implantée sur une falaise, la maison projette tous ses espaces communs vers le paysage grâce à des terrasses et balcons, protège la façade postérieure et s'adapte au terrain grâce à une combinaison de parements massifs et bois.

Emplazada en un acantilado, la casa proyecta todos sus espacios comunes hacia el paisaje mediante terrazas y balcones, protege la fachada posterior y se adapta al terreno combinando paramentos macizos con madera.

Situata su una falesia, la casa proietta tutti i suoi spazi di relazione e vita sociale verso il paesaggio mediante terrazzi e balconi, protegge la facciata posteriore e si adatta al terreno abbinando paramenti massicci con elementi in legno.

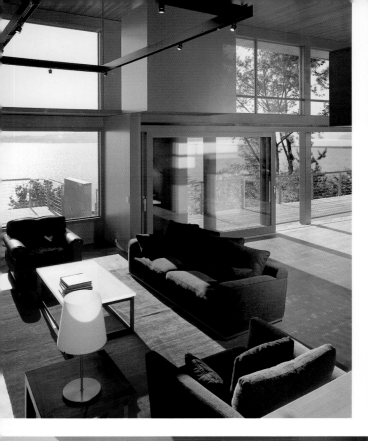
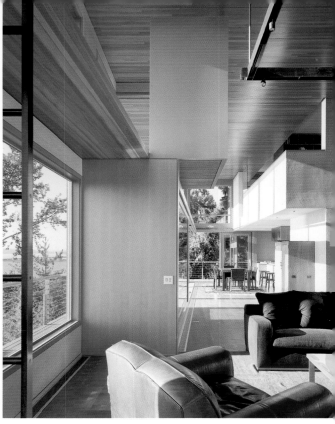
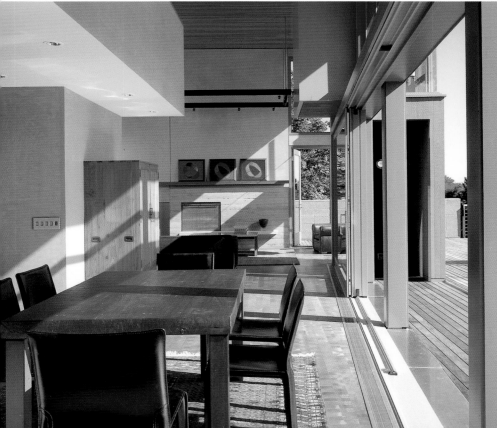

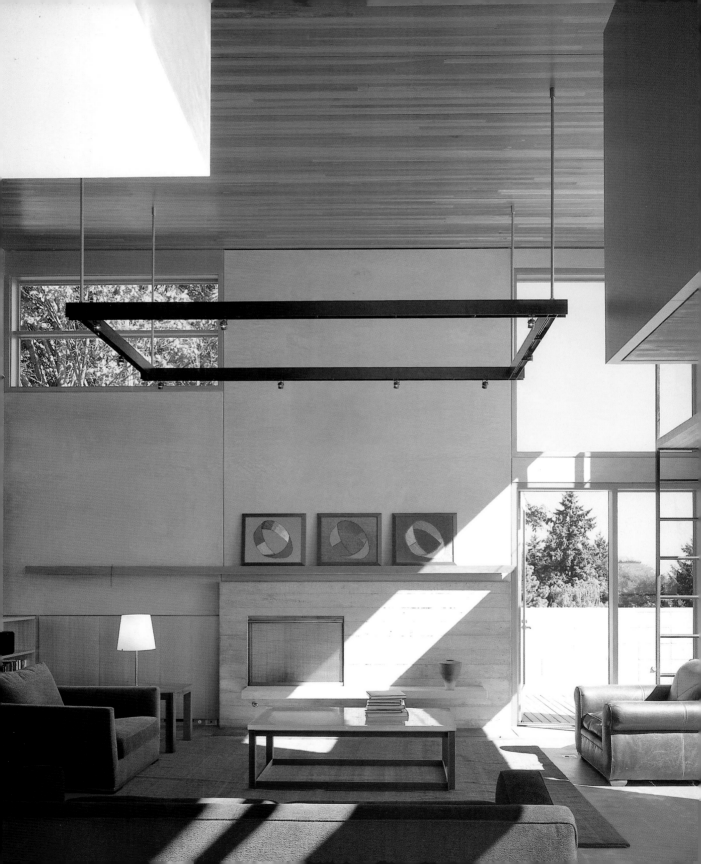

Schär-Valkanover House

Architects: Marcel Blum, Stefan Grossenbacher
Collaborators: Markus Meier, Schär Holzbau
Location: Grossdietwil, Switzerland
Year: 1998
Photography: Francesca Giovanelli

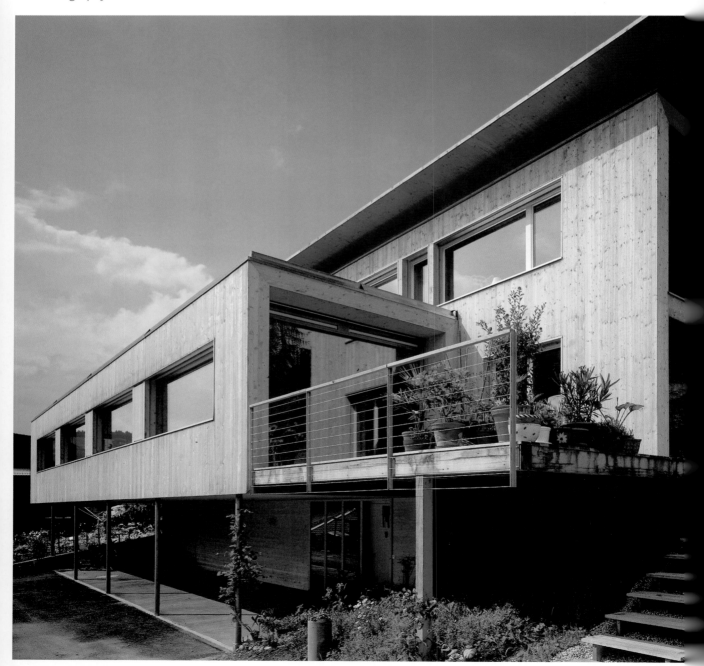

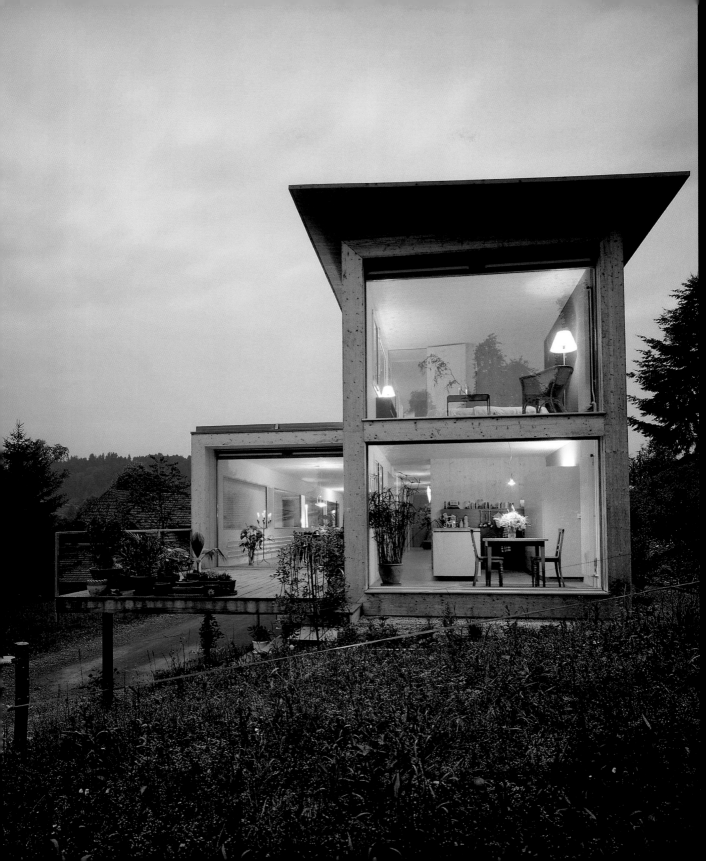

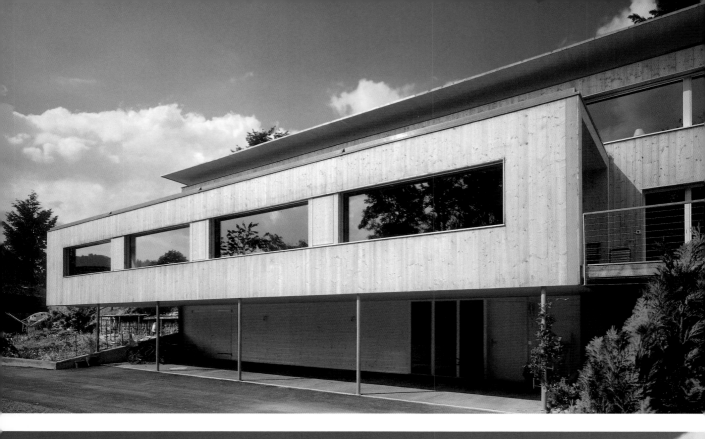
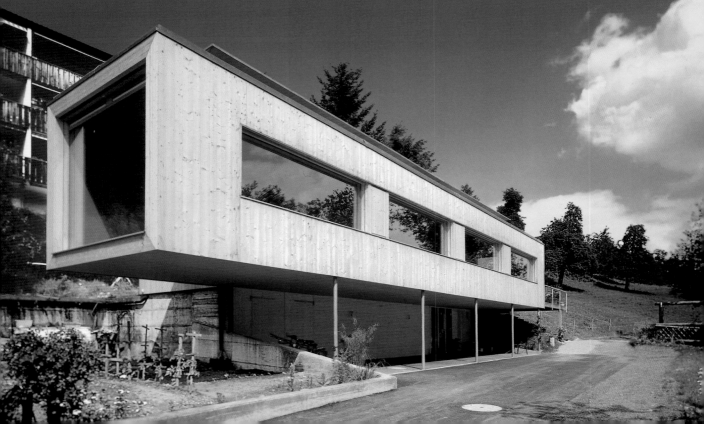

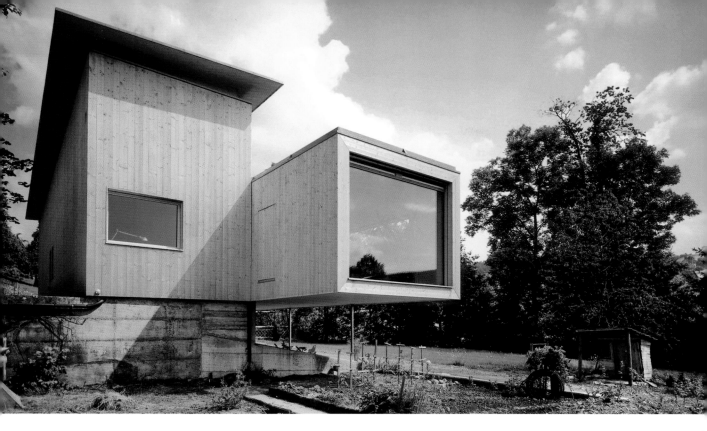

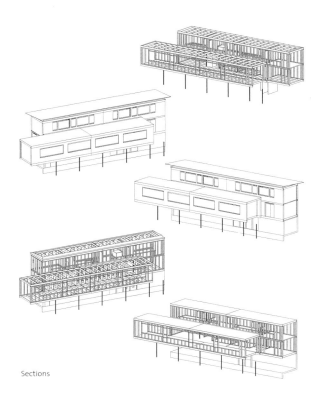

Sections

Two tetrahedrons, displaced in relation to each other, together constitute a volume that distributes three levels of night areas and one, on pillars, that contains the living room. Each of the rooms has been painted a different color from the rest.

Zwei Vierflächner, die zueinander verschoben sind, ergeben ein Gebäude mit drei Ebenen für die Schlafzimmer und einer Ebene auf Pfeilern, in der sich das Wohnzimmer befindet. Jeder Raum ist in einer anderen Farbe gestrichen.

Deux tétraèdres déplacés entre eux forment un volume qui distribue trois niveaux de zones de nuit et un, sur piliers, qui abrite le salon. A l'intérieur, les pièces à vivre sont peintes chacune dans une couleur différente.

Dos tetraedros desplazados entre sí conforman un volumen que distribuye tres niveles de zonas de noche y uno, sobre pilares, que contiene el salón. En el interior, las estancias se han pintado cada una de un color distinto.

Due tetraedri dislocati tra loro danno vita a un volume che distribuisce tre livelli adibiti a zona notte e un altro, supportato da pilastri, che contiene il salone. All'interno, le varie stanze sono state dipinte ognuna con un colore diverso.

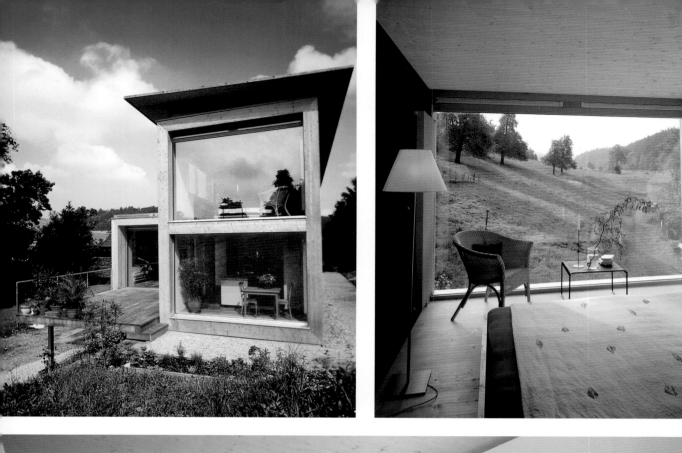

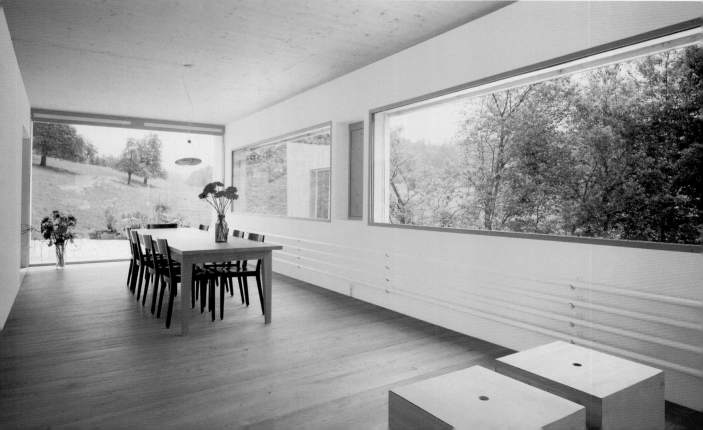

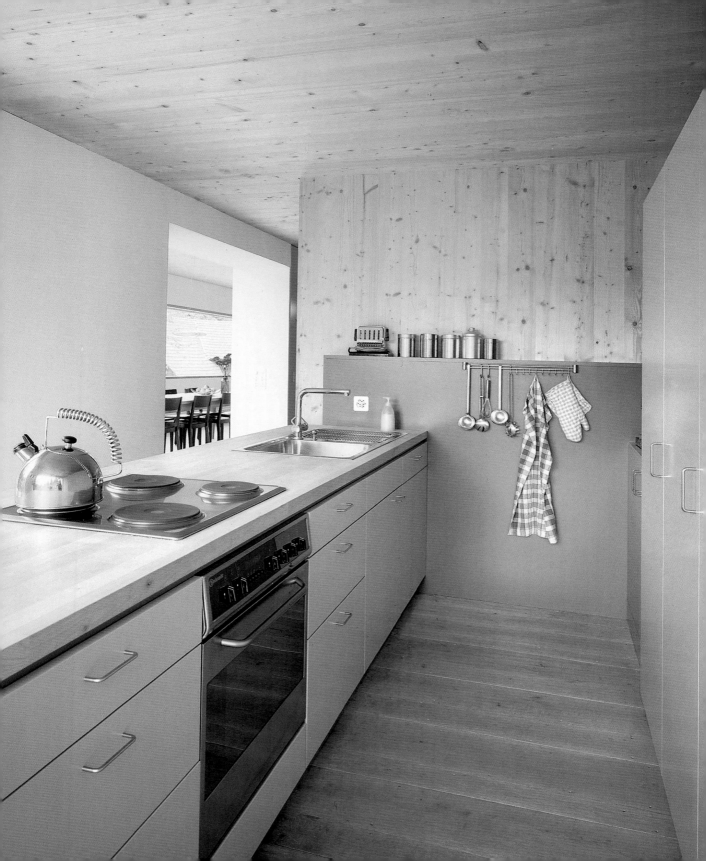

Weekend House

Architect: Ryue Nishizawa
Location: Usui-gun, Gunma, Japan
Year: 1998
Photography: Hisao Suzuki

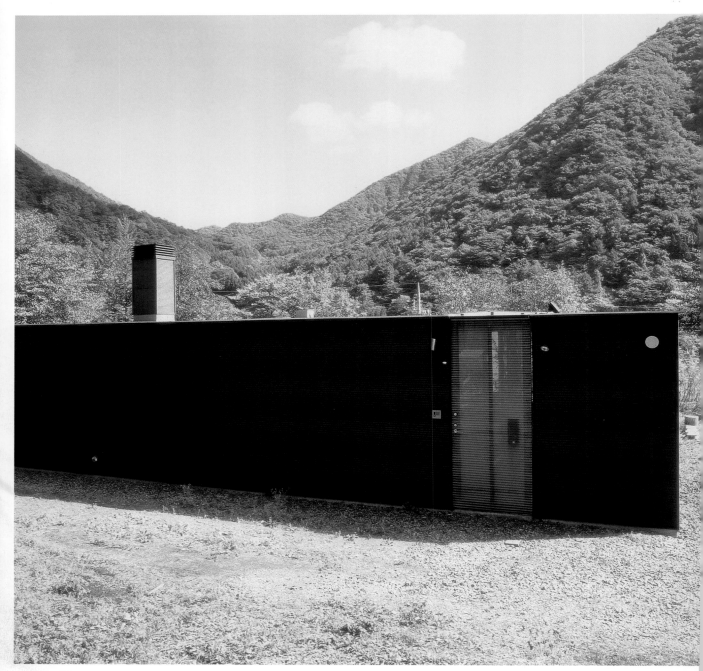

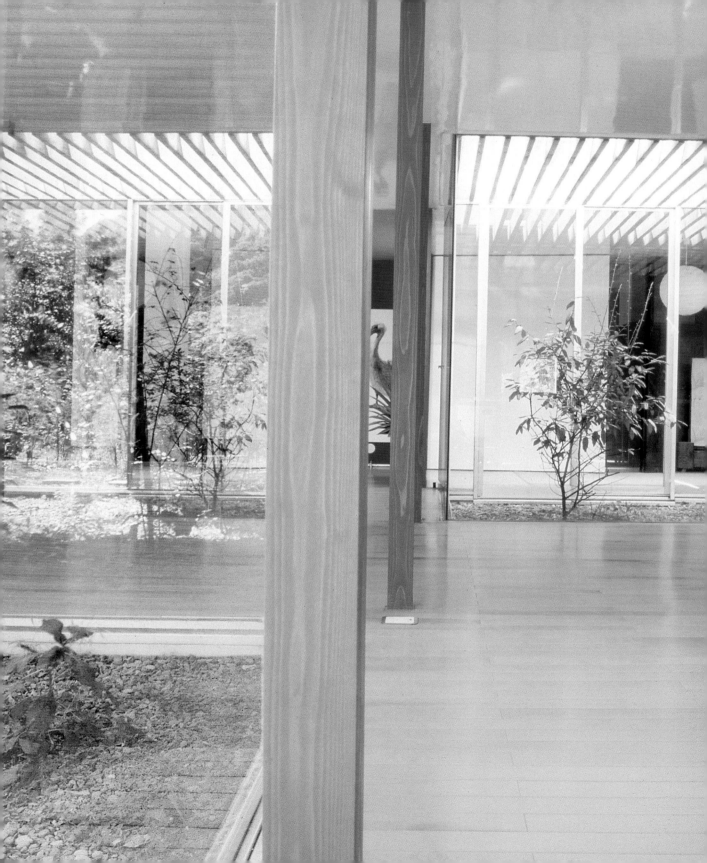

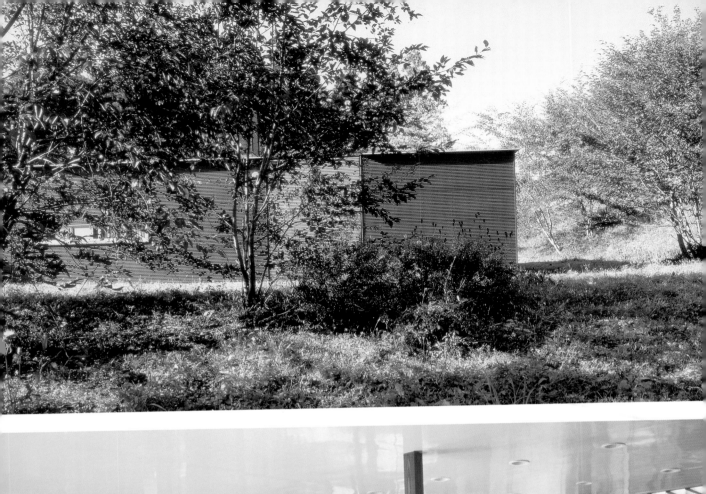

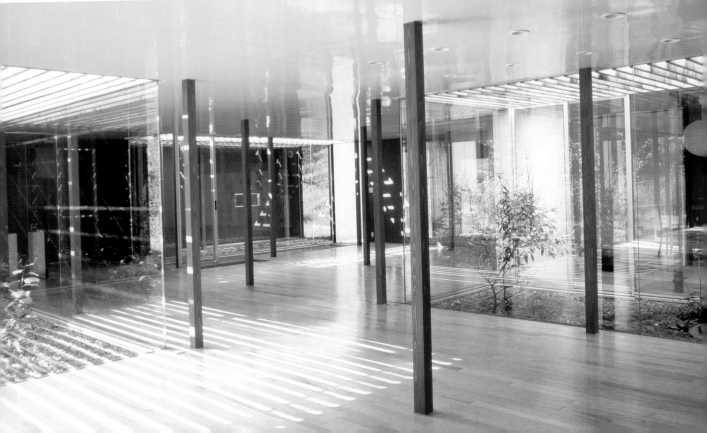

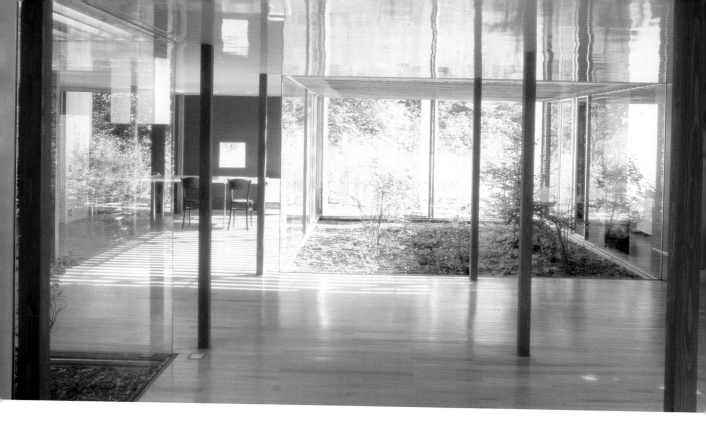

This single-floor house is both a home and an exhibition gallery. Consequently it is entirely closed to its surroundings, light entering in a controlled way from the patios.

Dieses einstöckige Haus dient sowohl als Wohnraum als auch als Ausstellungssaal. Es ist vollständig von seiner Umgebung abgeschlossen. Das Tageslicht fällt auf kontrollierte Weise durch die Innenhöfe ein.

Cette maison à un étage allie résidence et salle d'exposition, en se fermant entièrement aux alentours et en recevant un éclairage contrôlé grâce aux patios.

Esta casa de una sola planta combina su uso residencial con el de sala de exposiciones, por lo que se cierra completamente a su entorno y obtiene la iluminación de forma controlada a través de los patios.

Questa casa, di un solo piano, combina il suo uso residenziale con quello di sala per esposizioni, per cui si chiude completamente all'ambiente esterno e riceve l'illuminazione in maniera controllata attraverso i cortili.

Plan

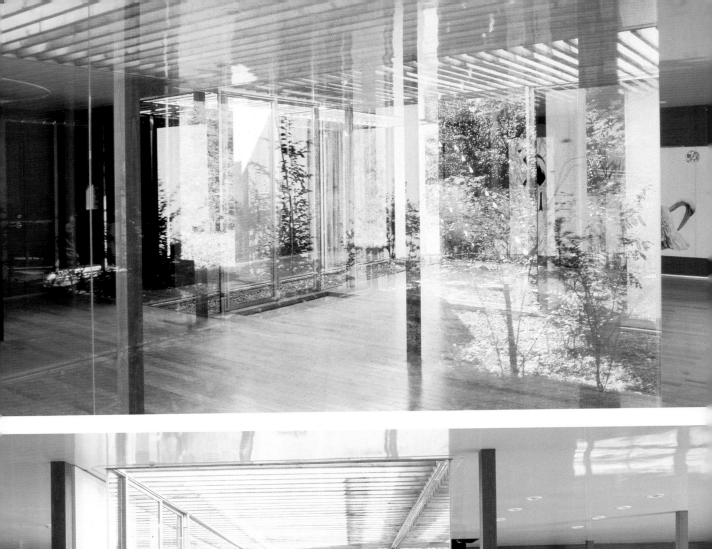
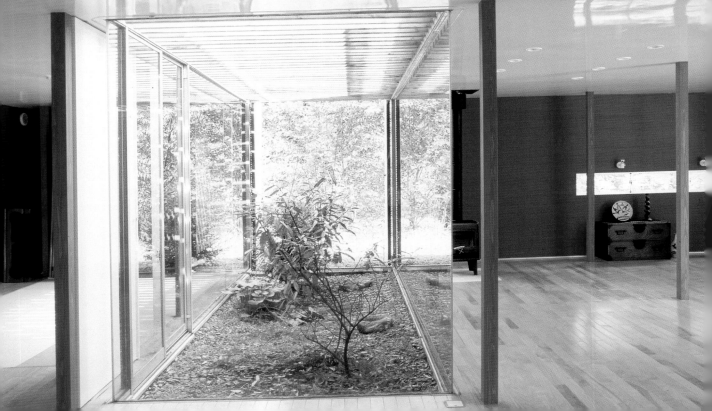

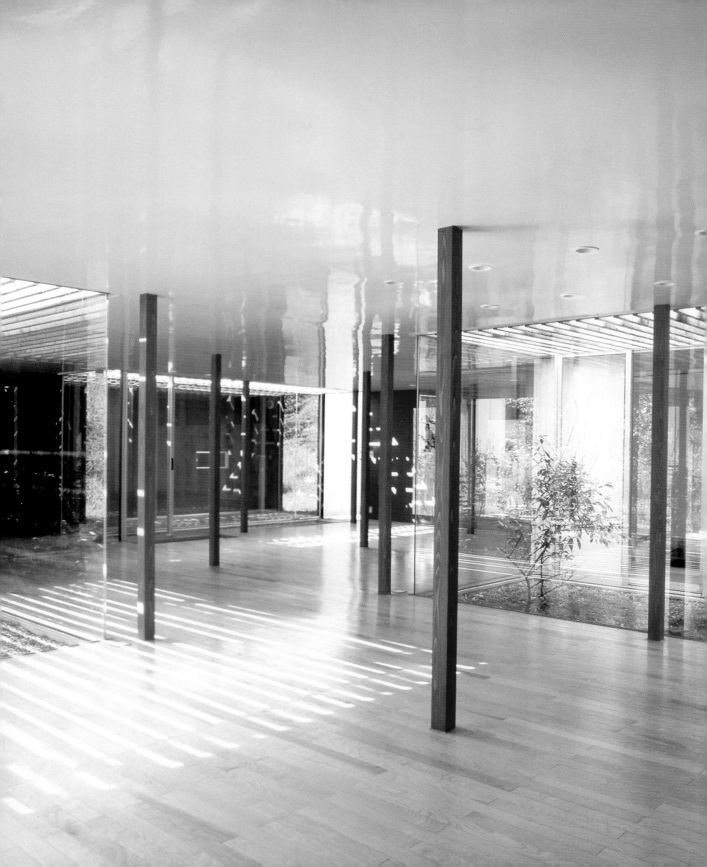

Mixed Structure Houses
Häuser mit gemischter Struktur
Maisons a structure mixte
Casas de estructura mixta
Case dalla struttura mista

The natural evolution of the wood house has led to the inclusion of new materials that contribute to obtaining a higher quality end product. Indeed, it is rare to find pure constructions in terms of use of material, either in the structure, in protection and thermal and sound conditioning, or in finishes. Today's wood houses of all types are built on foundations, normally of reinforced concrete, that not only provide structural stability but also separate the wood from the ground, thereby reducing damp. Furthermore, it is common practice to introduce metallic elements that optimize the support or structure, plastic materials or derivates that improve insulation and waterproofing, additions or treatments to protect the building against fire and damp and, finally, mixed panels made basically of recycled wood. These materials are all readily available on the market. Here follow a number of examples of mixed construction. Though by no means technologically sophisticated, they nonetheless respond to today's building needs. And while they mark no major qualitative leap forward in the evolution of wood house construction, they help to create a global vision.

Im Zuge der Weiterentwicklung der Holzbauweise wurden auch neue Materialien integriert, die die Qualität des Endproduktes verbessern. Es ist sowieso nicht einfach, ein Gebäude zu finden, das nur aus einer Art von Material konstruiert ist. Überall werden verschiedene Materialarten eingesetzt, sowohl bei der Struktur als auch bei den Elementen, die dem Schutz, der thermischen und akustischen Isolierung dienen und auch bei den Elementen der Verkleidung. Heutzutage werden Holzhäuser jeder Bauart auf einem Fundament errichtet, das normalerweise aus Stahlbeton besteht. Dieses Fundament verleiht dem Haus eine strukturelle Stabilität und es bildet eine Barriere zwischen dem Untergrund und dem Holz, was die Feuchtigkeit reduziert. Ein weiteres gutes Beispiel für den Einsatz unterschiedlicher Materialien ist die Einführung von Elementen aus Metall, die die Träger und die Struktur stärken. Ebenso dienen aus Kunststoff hergestellte Materialien einer besseren Isolierung und dem Feuchtigkeitsschutz und das Holz wird mit neuen Systemen und Materialien behandelt, um die Feuerfestigkeit und die Widerstandsfähigkeit gegen Feuchtigkeit zu verbessern. Und schließlich werden auch Paneele aus verschiedenen Materialien auf der Grundlage von Recyclingholz hergestellt. All diese Materialien sind leicht auf dem Markt zu finden, es handelt sich keinesfalls um seltene Produkte. Im folgenden stellen wir Ihnen einige moderne Beispiele der gemischten Bauweise vor. Es handelt sich nicht um technologisch überdurchschnittlich entwickelte Lösungen, sondern um einfache Beispiele der heutigen Bauweise. Diese Gebäude stellen keinen Quantensprung in der Entwicklung des Holzhauses dar, aber sie vermitteln einen guten Überblick.

L'évolution naturelle de la maison en bois tend à intégrer de nouveaux matériaux pour obtenir un produit final de meilleure qualité. De toutes façons, il est assez difficile de trouver des constructions purement en bois, que ce soit au niveau de la structure, des matériaux de protection et de conditionnement thermique et phonique et enfin, des finitions. A l'heure actuelle, les constructions en bois de tous les types constructifs sont installées sur des fondations, généralement en béton armé, assurant à la fois une stabilité structurelle tout en séparant le bois du terrain pour protéger de l'humidité. L'exemple parfait est l'introduction d'éléments métalliques d'optimisation du support ou de l'ossature, de matières plastiques ou de dérivés pour améliorer l'isolement et l'imperméabilisation, suppléments ou traitements destinés à offrir de nouveaux éléments de protection contre l'incendie et l'humidité, et finalement l'élaboration de panneaux mixtes à partir de bois recyclés. En outre, il est relativement facile d'acquérir tous ces éléments sur le marché. Voici quelques exemples actuels de construction mixte, dépourvus de sophistication technologique et correspondant tout simplement à la réalité constructive actuelle. Sans présenter d'avancée qualitative dans l'évolution de la construction de maisons en bois, ils en offrent néanmoins une vue d'ensemble.

La evolución natural de la casa de madera lleva a la inclusión de nuevos materiales que ayudan a conseguir un producto final de mayor calidad. De todas formas, resulta bastante difícil encontrar construcciones puras desde el punto de vista de la utilización del material, ya sea en la estructura, en los materiales de protección y acondicionamiento térmico y acústico o en los acabados. En la actualidad, las edificaciones de madera de todos los tipos constructivos se construyen sobre una cimentación, normalmente de hormigón armado, que no sólo proporciona estabilidad estructural, sino que separa la madera del terreno y reduce la humedad. Buena muestra de ello es la introducción de elementos metálicos de optimización del soporte o estructura, materiales plásticos o derivados para mejorar el aislamiento y la impermeabilización, añadidos o tratamientos destinados a proporcionar nuevas características de protección contra el fuego y la humedad, y finalmente la elaboración de paneles mixtos a partir de maderas recicladas. Todo ello resulta relativamente fácil de adquirir en el mercado. A continuación, se muestran algunos ejemplos actuales de construcciones mixtas; aunque no son tecnológicamente sofisticadas, responden a la realidad constructiva actual y, si bien no representan ningún gran salto cualitativo en la evolución de la construcción de casas de madera, ayudan a crear una visión global.

L'evoluzione naturale della casa in legno porta ad includere e adoperare nuovi materiali grazie ai quali si ottiene un prodotto finale di maggiore qualità. Ad ogni modo, risulta abbastanza difficile trovare costruzioni pure sia dal punto di vista dell'uso dei materiali, sia nella struttura, negli impianti di protezione e nelle finiture. Attualmente, gli edifici in legno realizzati nei vari tipi di modalità costruttive, vengono fabbricati su delle fondamenta, normalmente in cemento armato, che non solo conferiscono una stabilità strutturale ma separano il legno dal terreno e riducono l'umidità. Ne è un ottimo esempio l'introduzione di elementi metallici che ottimizzano il supporto o la struttura, di materiali plastici o derivati volti a migliorare l'isolamento e l'impermeabilità, trattamenti destinati a fornire nuove caratteristiche protettive contro il fuoco, l'umidità, o in ultimo, l'elaborazione di pannelli misti a partire da legname riciclato. Il tutto è facilmente reperibile sul mercato. Qui di seguito, vengono mostrati alcuni esempi attuali di costruzione mista; non sono tecnologicamente sofisticati, ma rispondono alla realtà costruttiva attuale e sebbene non rappresentino un gran salto di qualità nell'evoluzione costruttiva delle case in legno, aiutano a darne una visione globale.

Avalon House

Architect: Connor + Solomon Architects
Location: Sydney, Australia
Year: 2003
Photography: Peter Scott

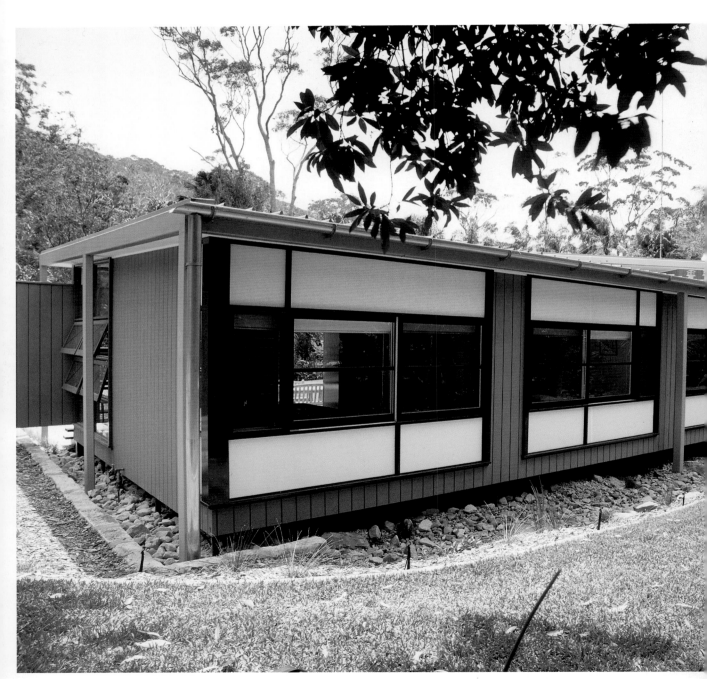

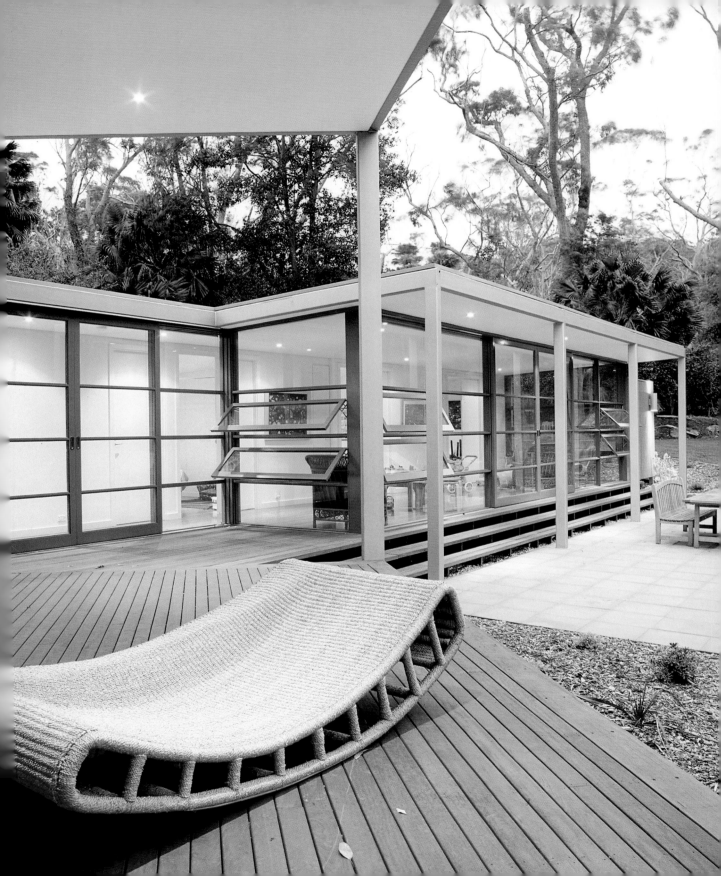

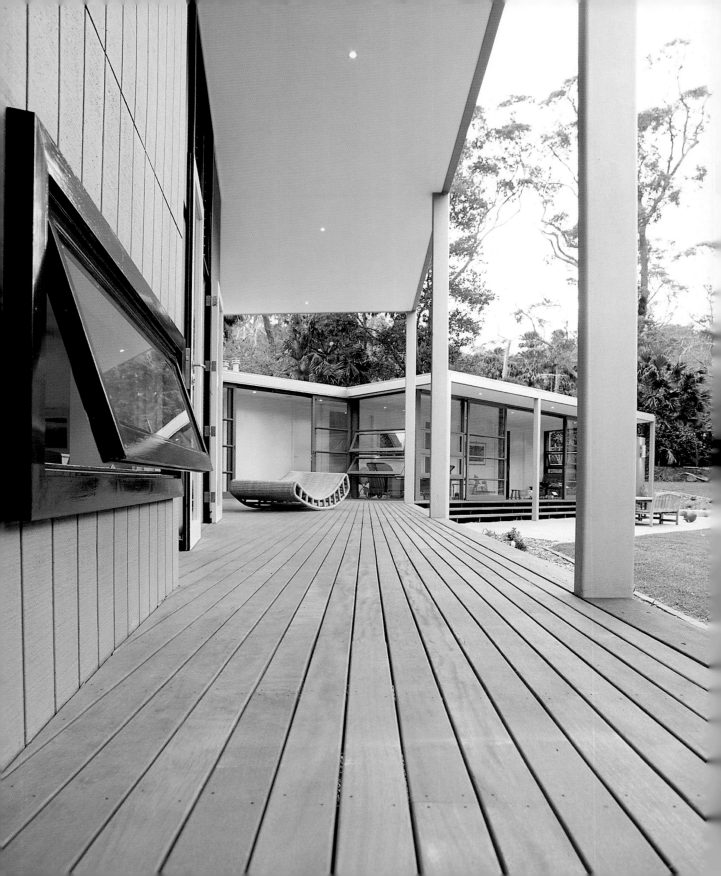

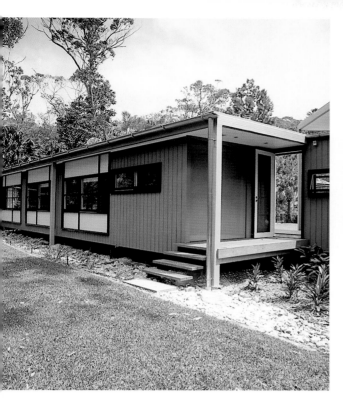

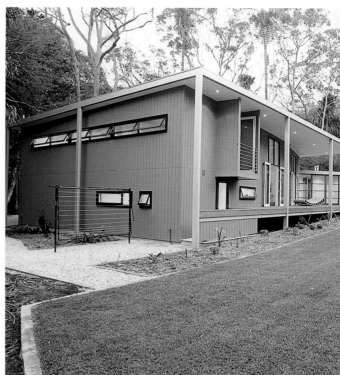

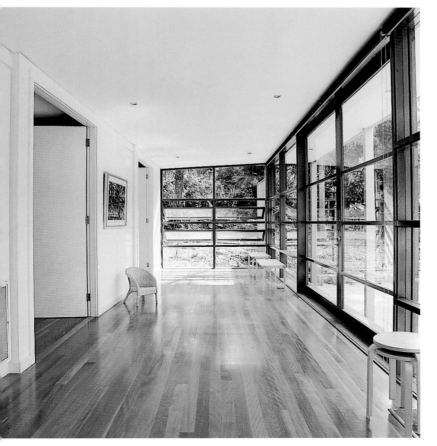

Two blocks with slightly different angles collide at one of their corners to form the volume of the house. The south-facing façade is entirely glazed and rests on a wooden terrace.

Zwei Blöcke mit leicht verschiedenen Winkeln stoßen an ihren Ecken zusammen und bilden so die Form dieses Hauses. Die Südfassade ist vollständig verglast und stützt sich auf eine Holzterrasse.

La volumétrie de la maison est constituée par deux blocs aux angles légèrement distincts, se rencontrant à l'un d'entre eux. La façade sud est entièrement vitrée et repose sur une terrasse en bois.

Dos bloques con ángulos ligeramente distintos colisionan en una de sus esquinas y forman la volumetría de la casa. La fachada sur está completamente acristalada y descansa sobre una terraza de madera.

Due blocchi con angoli leggermente diversi entrano in collisione in uno dei loro angoli dando vita alla volumetria della casa. La facciata sud è completamente vetrata e si adagia su un terrazzo di legno.

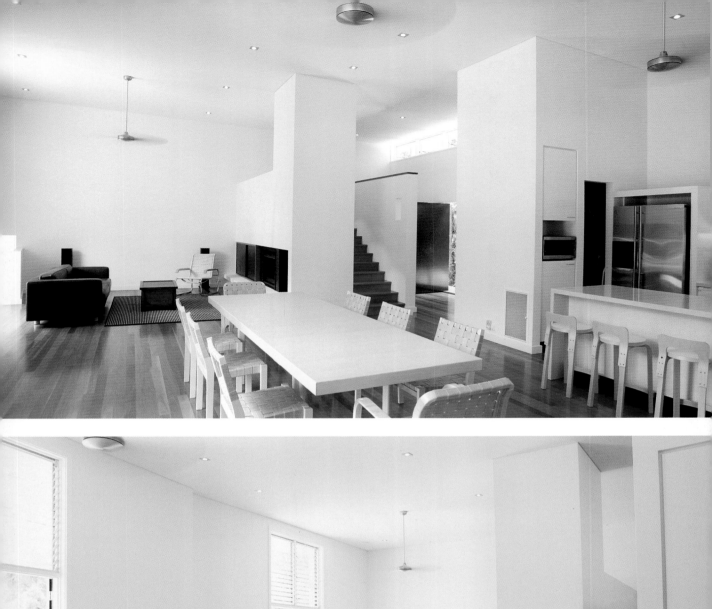
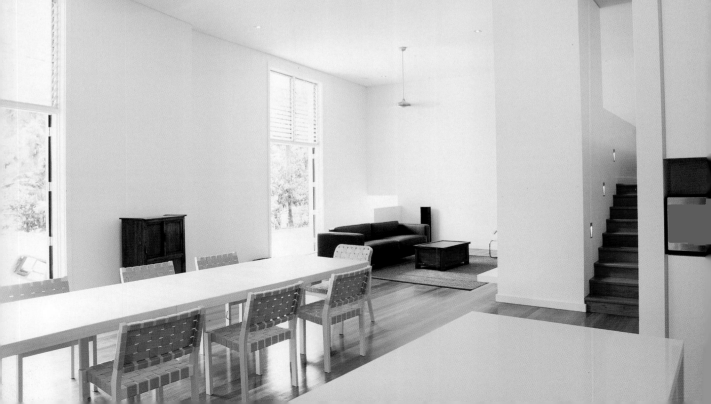

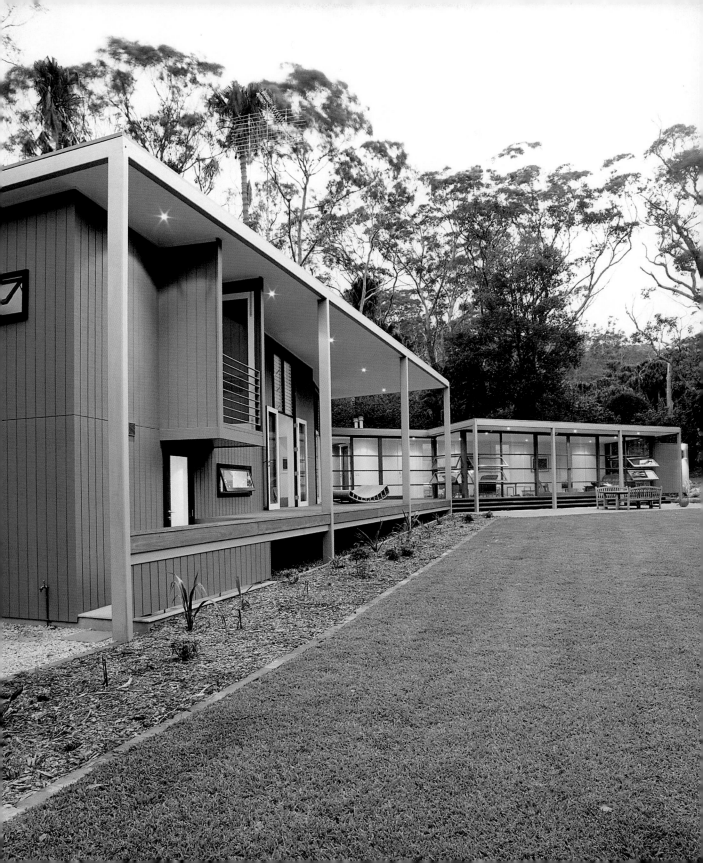

Minton Hill House

Architect: Affleck + De la Riva Architectes
Location: North Hatley, Quebec, Canada
Year: 2003
Photography: Marc Cramer

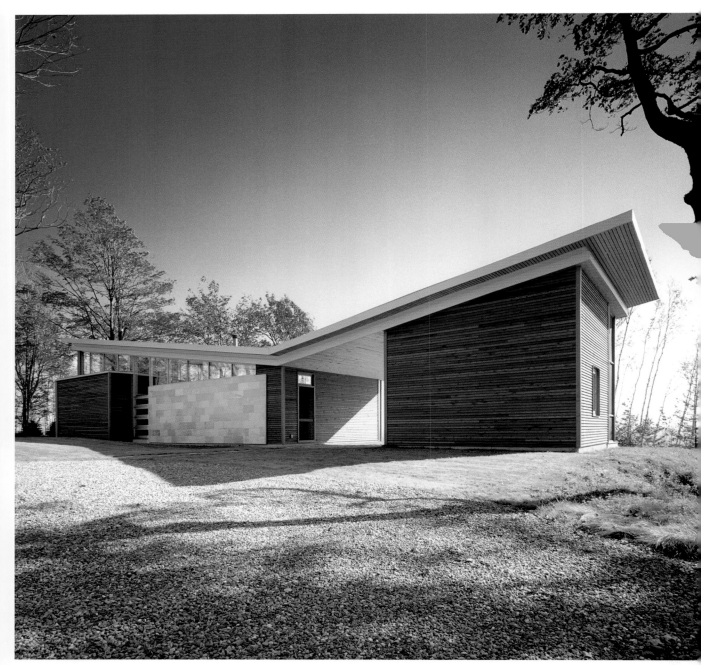

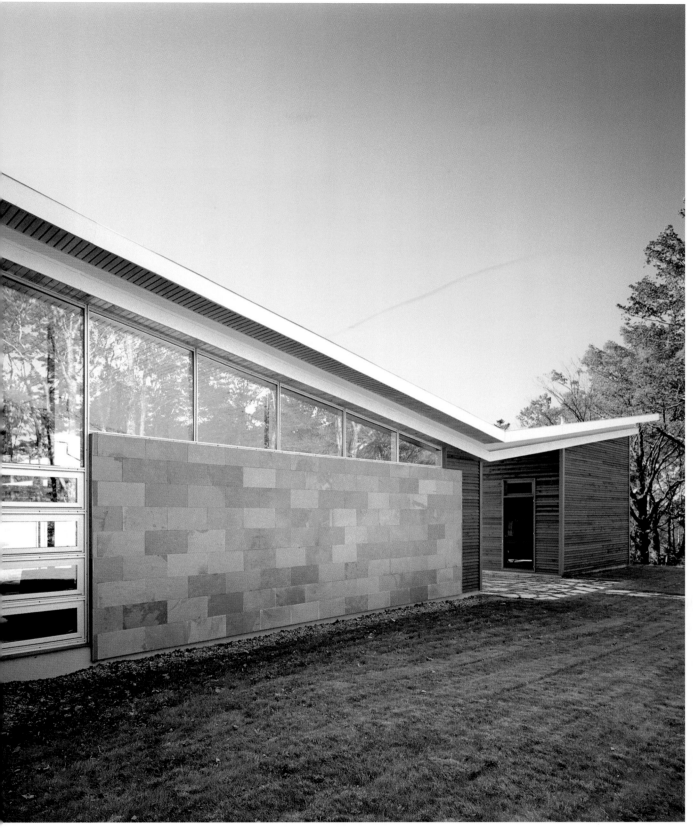

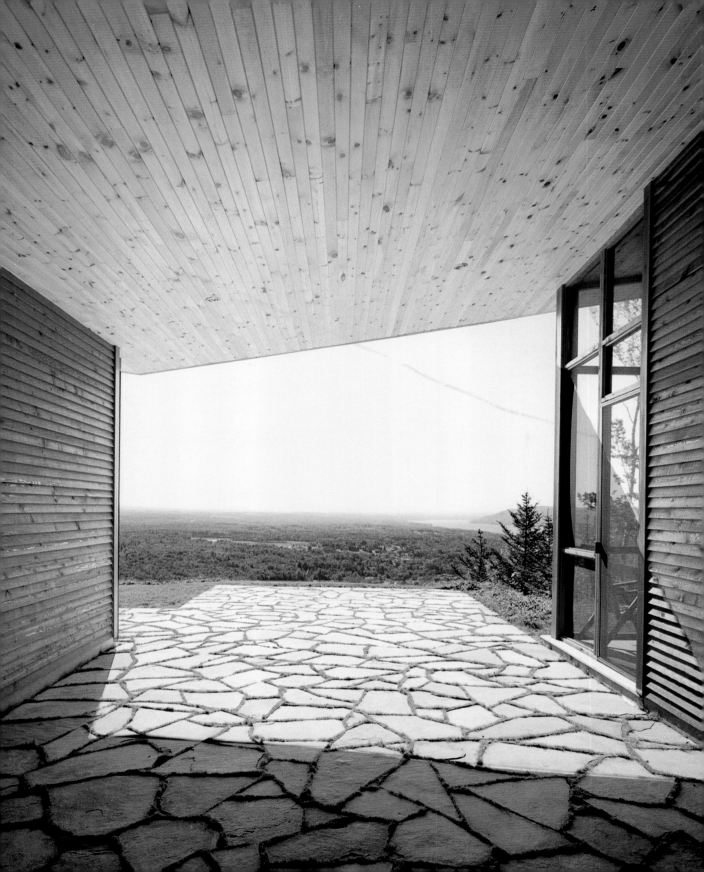

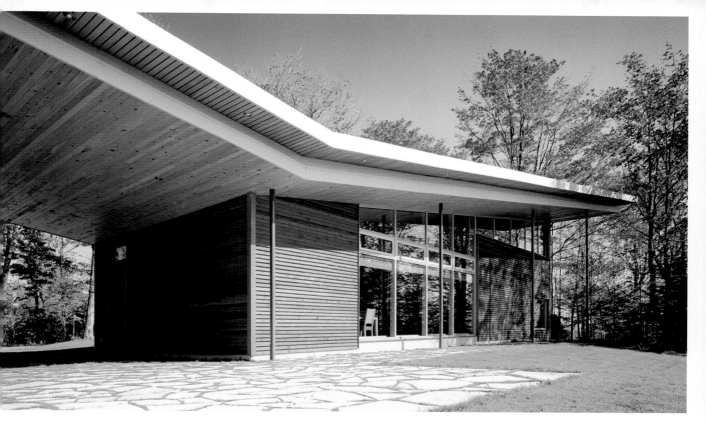

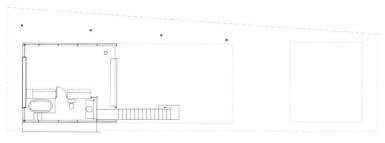

Upper floor plan

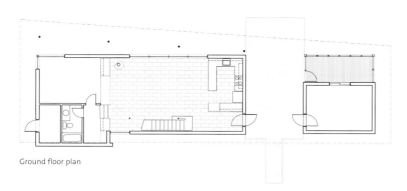

Ground floor plan

Dramatically located on the crest of a hill, the house is split into two bays joined by the roof: on one side the home itself and on the other the only occupant's work space.

Dieses Haus steht oben auf einem Hügel und unterteilt sich in zwei Teile, die durch das Dach verbunden werden. In einem Teil liegt der eigentliche Wohnbereich und in dem anderen Teil der Arbeitsraum des einzigen Bewohners.

Située dans un décor de théâtre, au sommet d'une colline, la résidence est divisée en deux corps unis par la toiture : d'un côté, l'habitation à proprement dit et, de l'autre, l'aire de travail de son unique habitant.

Dramáticamente situada en la cumbre de una colina, la residencia se divide en dos cuerpos unidos por la cubierta: por un lado, la vivienda propiamente dicha y, por el otro, el espacio de trabajo de su único ocupante.

Questa abitazione, situata drammaticamente in cima a una collina, si divide in due corpi uniti dalla copertura: da un lato l'abitazione propriamente detta e dall'altro la spazio di lavoro del suo unico occupante.

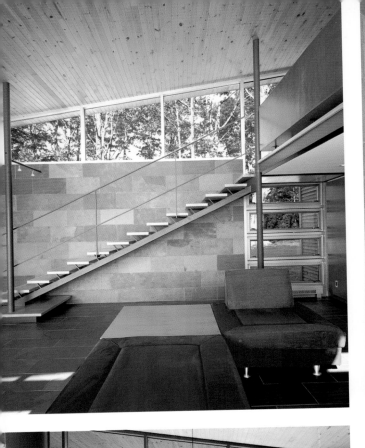
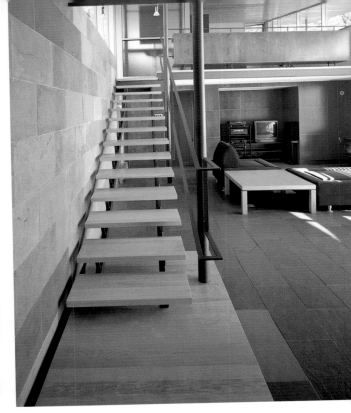
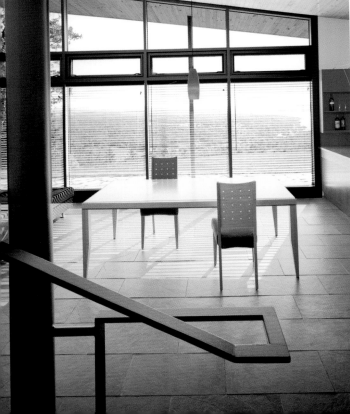
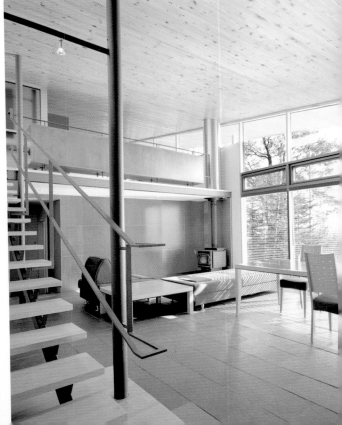

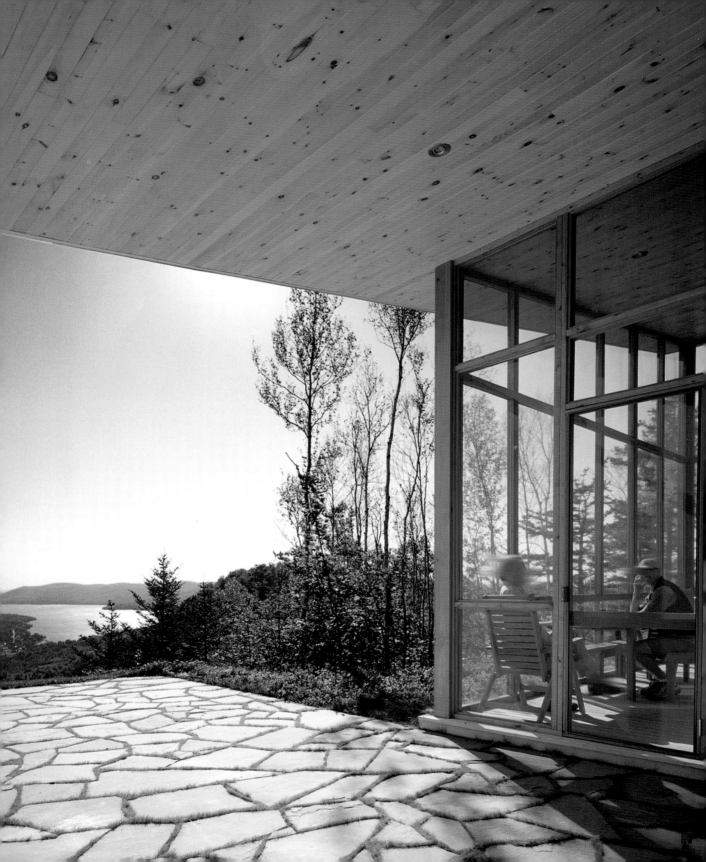

Albrecht Residence

Architect: Salmela Architecture & Design

Location: Redwing, MN, USA

Year: 2003

Photography: Peter Bastianelli-Kerze

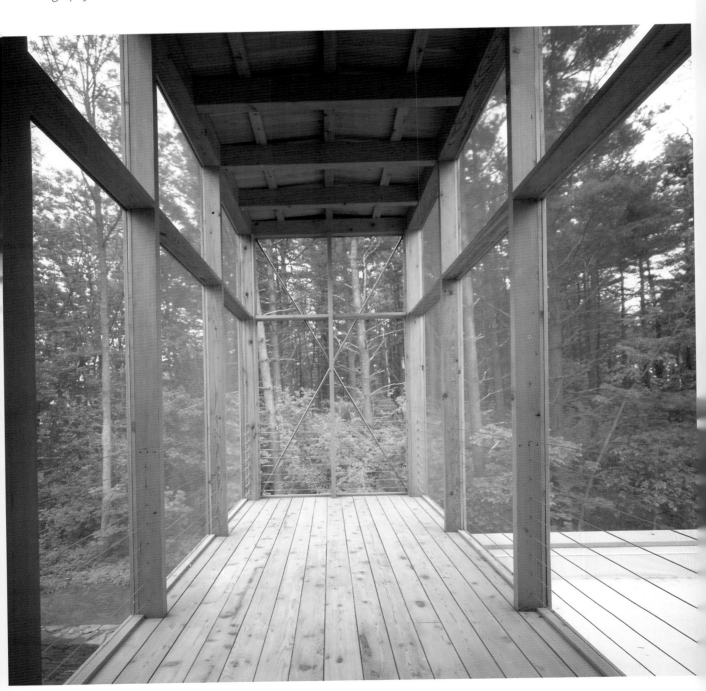

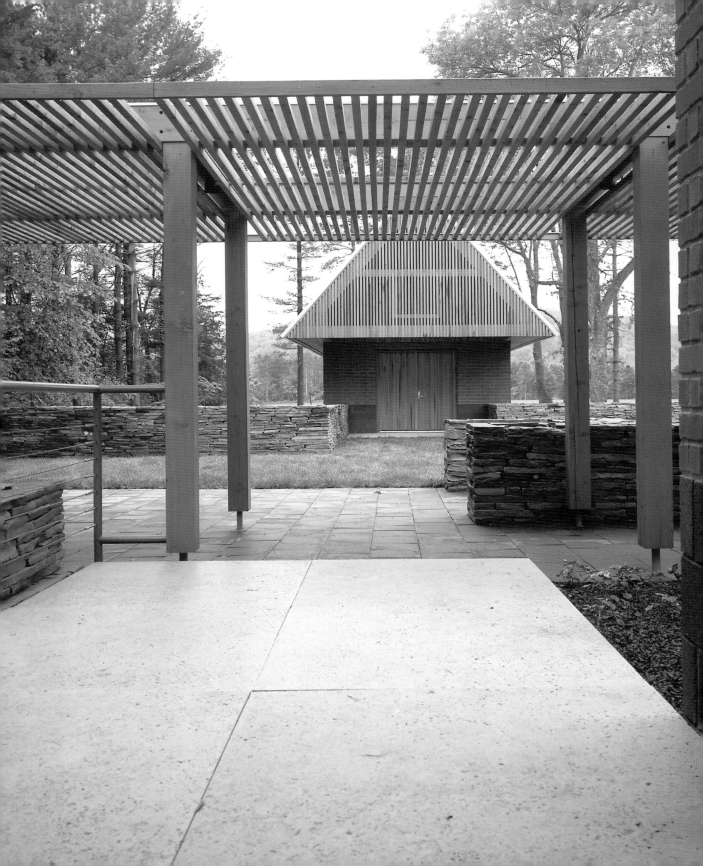

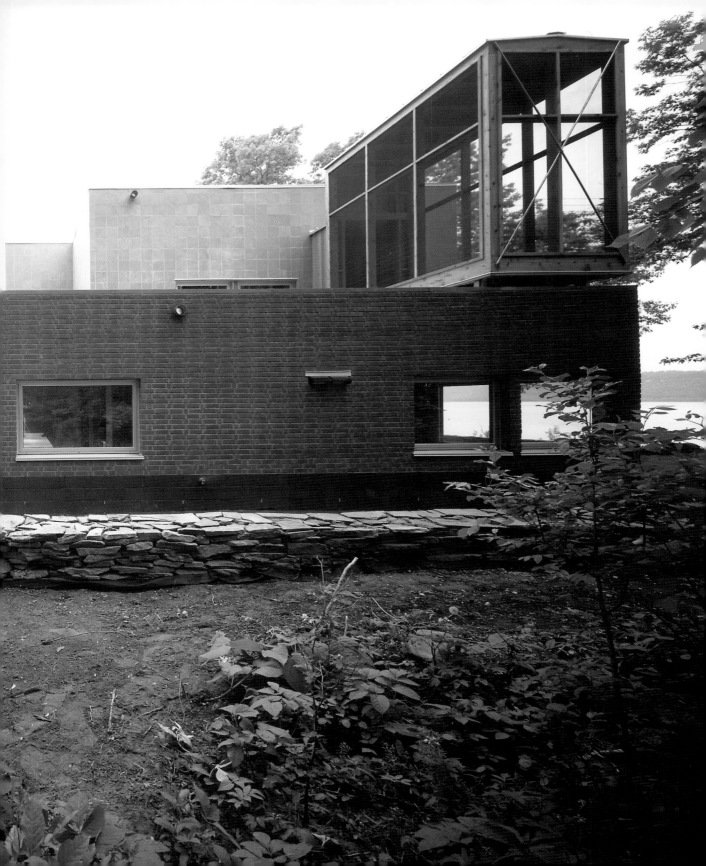

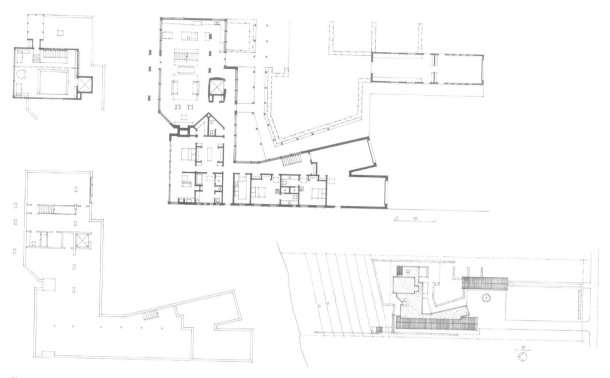

Plans

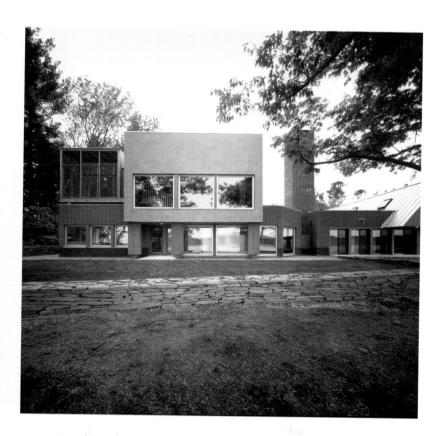

A house of large dimensions characterized by the flowing inner space, the rich finishes in wood and the continuity with the exterior through pergolas, galleries and terraces.

Dieses große Wohnhaus zeichnet sich durch Räume aus, die sehr fließend wirken, durch die wundervollen Oberflächen aus Holz und durch die Kontinuität, die durch Pergolen, Galerien und Terrassen nach außen entsteht.

Habitation aux grandes dimensions qui se détache pour sa fluidité spatiale intérieure, la richesse de ses finitions en bois et la continuité avec l'extérieur grâce à des pergolas, galeries et terrasses.

Vivienda de grandes dimensiones que destaca por la fluidez de su espacio interior, la riqueza de sus acabados en madera y la continuidad con el exterior a través de pérgolas, galerías y terrazas.

Abitazione dalle grandi dimensioni che spicca per la fluidità degli spazi interni, la ricchezza delle sue finiture in legno e la continuità con l'esterno ottenuta mediante pergole, verande e terrazzi.

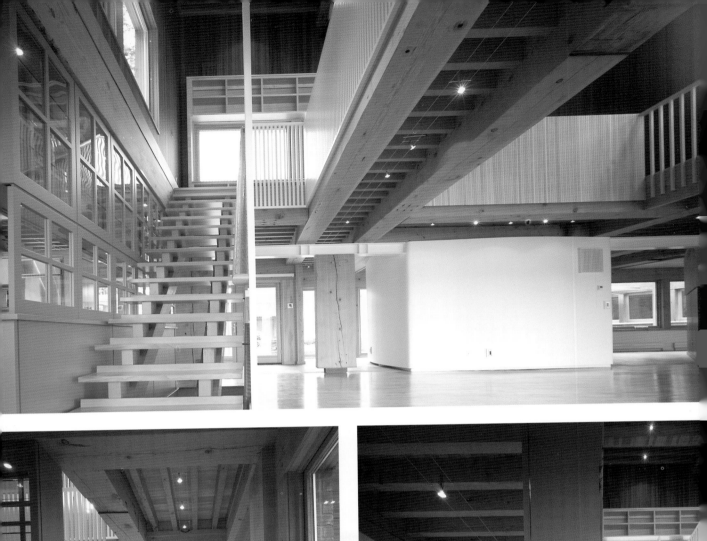
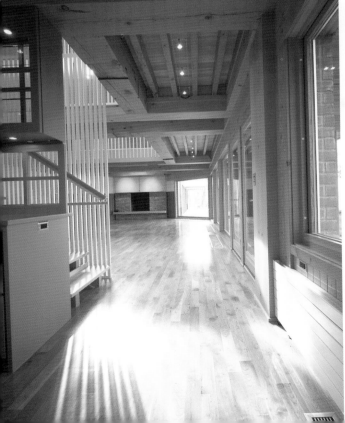
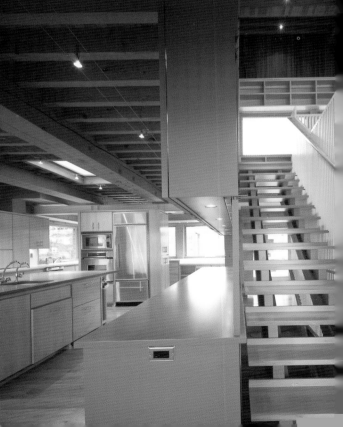

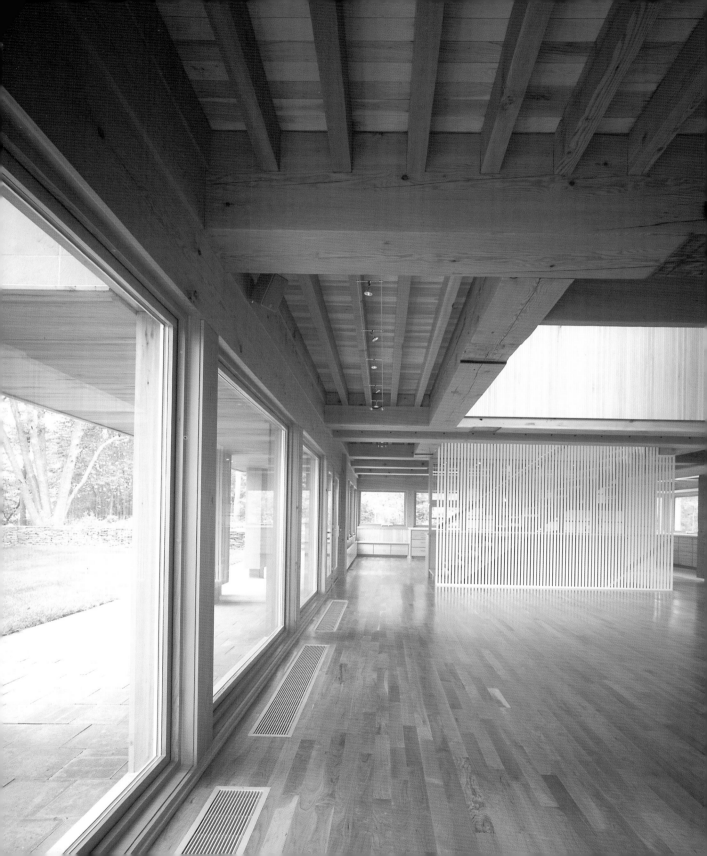

House R

Architects: Wolfgang Feyferlik, Susi Fritzer
Location: Graz, Austria
Year: 2002
Photography: Paul Ott

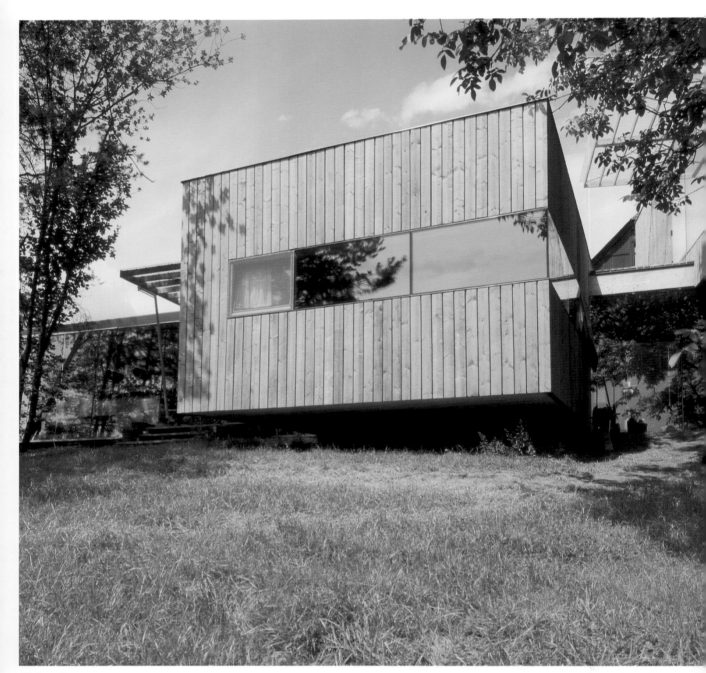

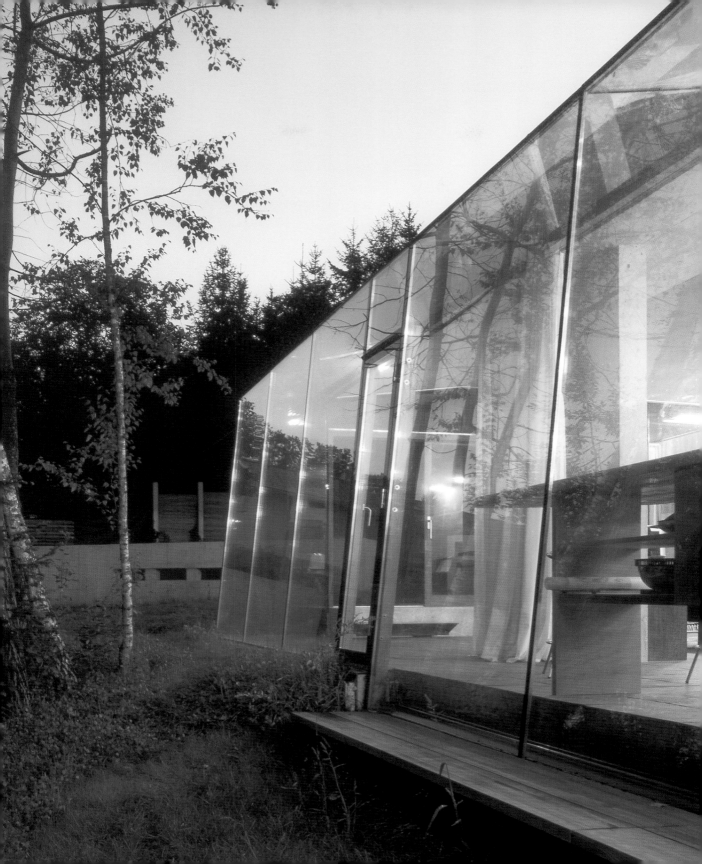

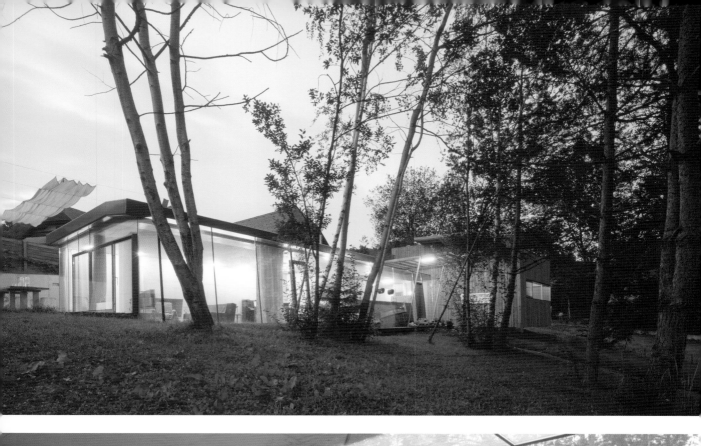

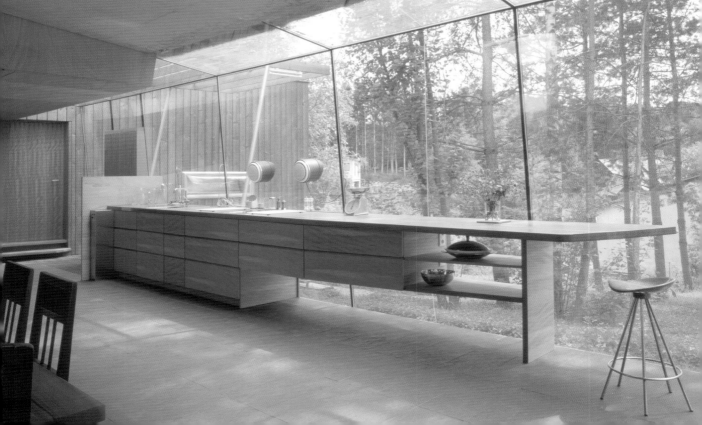

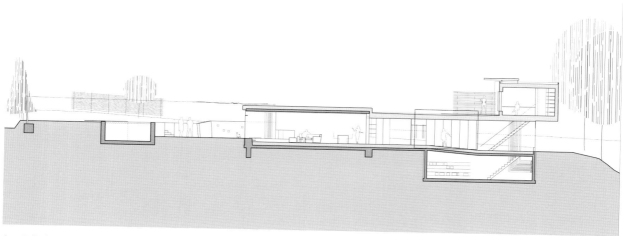

Longitudinal section

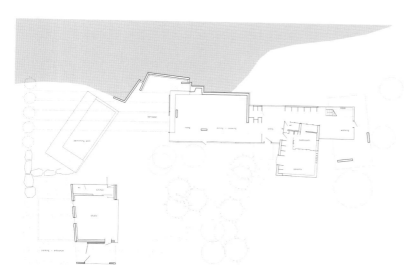

Ground floor

Perched on the crest of a south-west descending slope, this house imitates a miniature village through the sum of volumes and activities to attend to the needs of the family, a tiny community.

Dieses Wohnhaus, das oben auf einem Südwesthang steht, ist einem Dorf in Miniatur nachempfunden. Diese Wirkung beruht auf den verschiedenen Gebäudeteilen und Aktivitäten, denen die Familie nachgeht. Es entstand eine kleine Gemeinschaft.

Au sommet d'une pente orientée sud-ouest, cette habitation est conçue à l'instar d'un village en miniature, grâce à l'addition de volumes et d'activités pour accueillir la famille, une petite communauté en soi.

El diseño de esta vivienda, en la cumbre de una pendiente hacia el suroeste, evoca un pueblo en miniatura, mediante la suma de volúmenes y actividades para atender a una familia, una pequeña comunidad.

Il disegno di questa abitazione, posta in cima a un pendio verso sudovest, imita quello di un paesino in miniatura, mediante la somma di volumi e attività che fanno fronte alle esigenze di una famiglia, una piccola comunità.

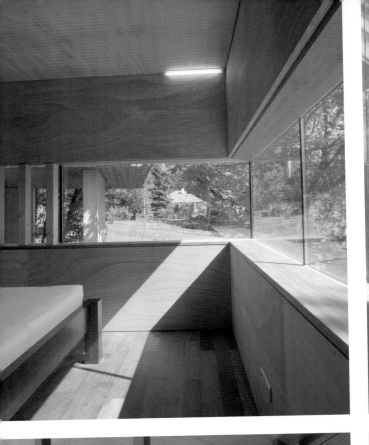
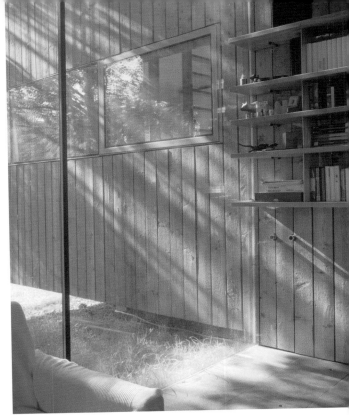
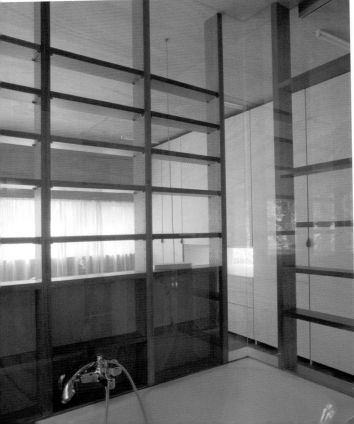
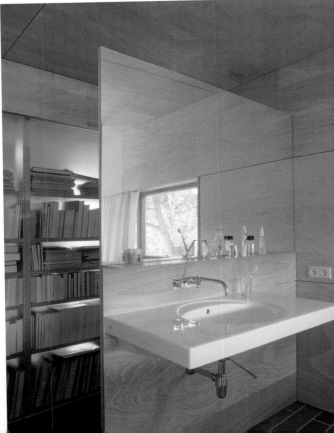

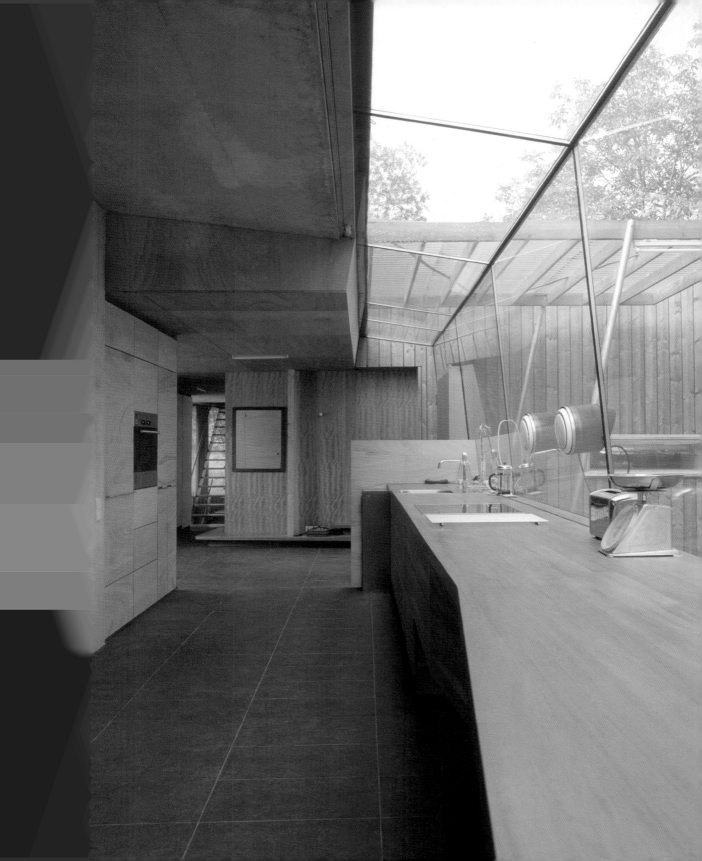

Cavegn House

Architect: Ivan Cavegn Architekturbüro
Location: Rothis, Austria
Year: 2002
Photography: Albrecht Immanuel Schnabel

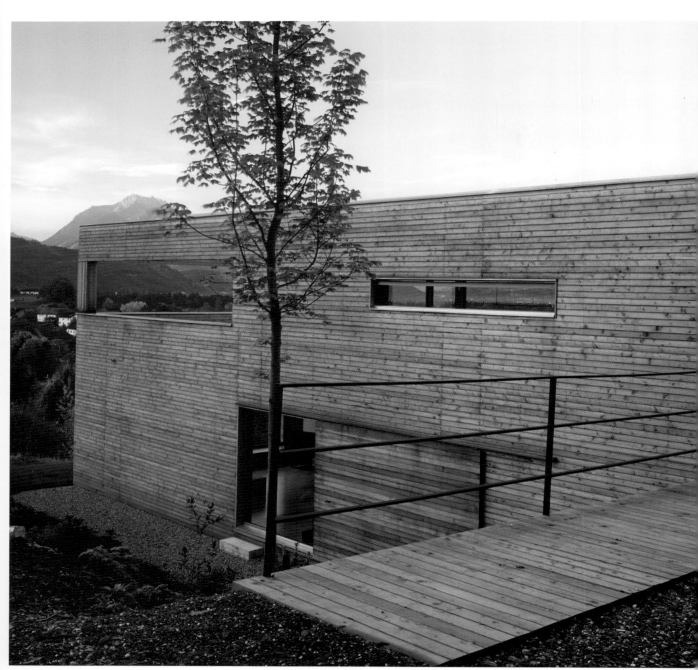

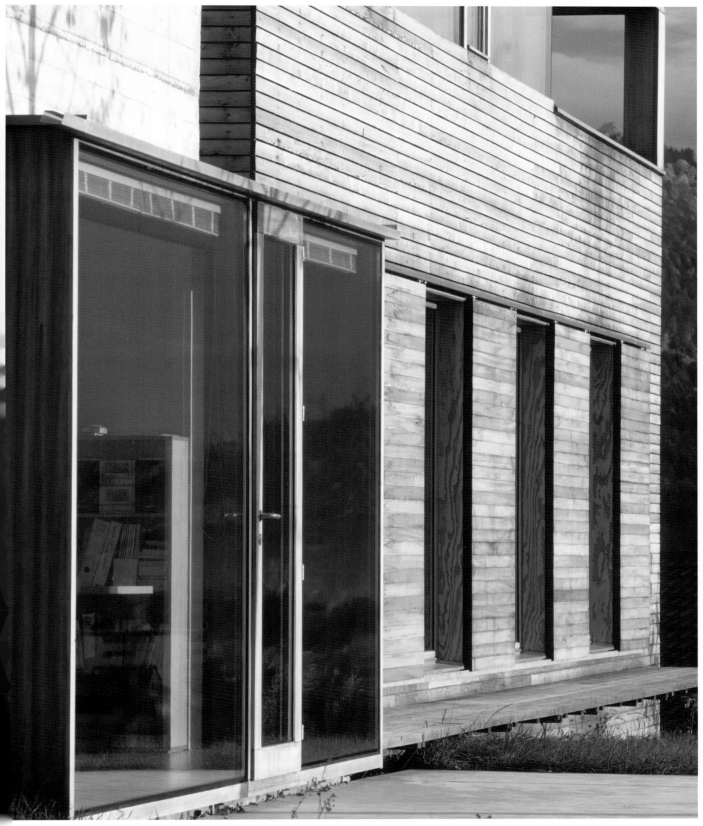

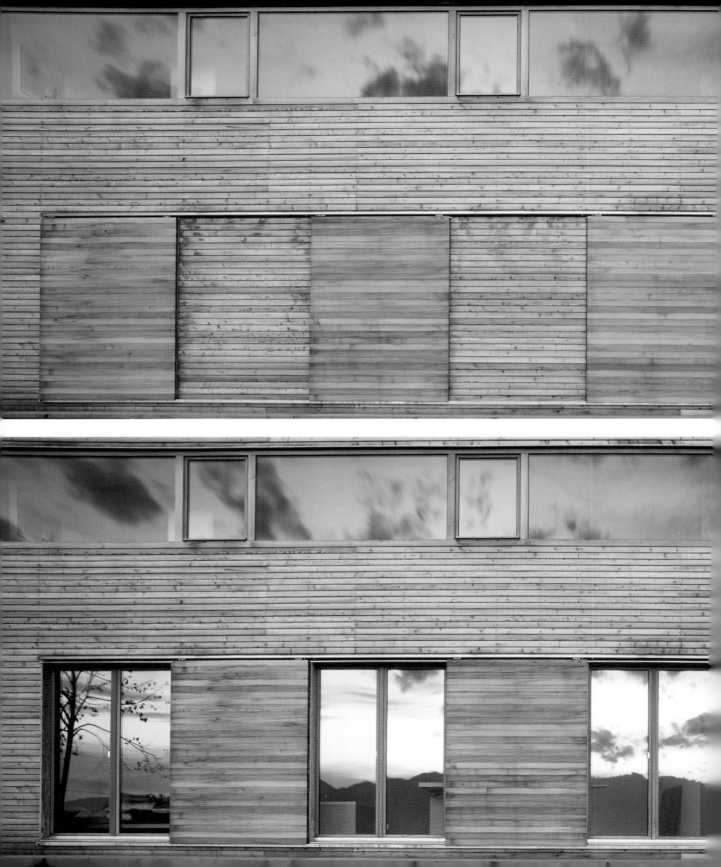

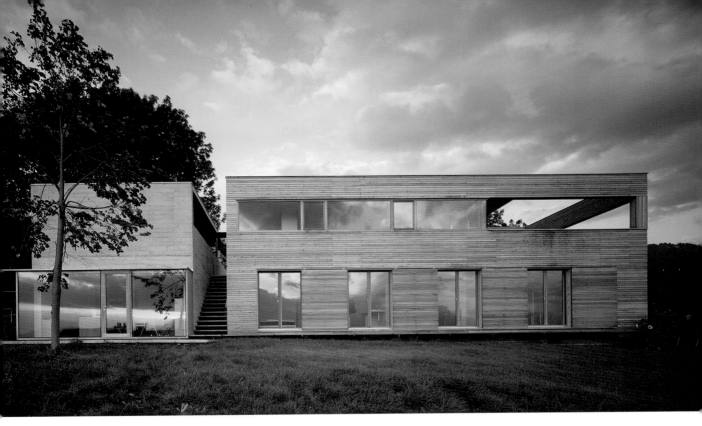

A single volume is split by a catwalk and a staircase. Use—dwelling and study—and material—concrete blocks and wood—differentiate the two parts of the building.

Dieses Haus besteht aus einem einzigen Gebäude, das durch einen Laufsteg und eine Treppe unterteilt wird. Es dient als Wohnraum und Atelier und die beiden Teile des Hauses werden durch die verwendeten Materialien – ein Betonblock und Holz – unterschieden.

Un unique volume est séparé par une passerelle et un escalier. La fonction, habitation et studio, et la matière, bloc de béton et bois, permettent de différencier les deux parties de l'édifice.

Un único volumen está separado por una pasarela y una escalera. El uso, vivienda y estudio, y el material, bloque de hormigón y madera, acaban de diferenciar las dos partes de la edificación.

Un unico volume rimane separato da una passerella e una scala. L'uso, abitazione e studio, e il materiale adoperato, blocco di cemento e legno, finiscono per differenziare le due parti della costruzione.

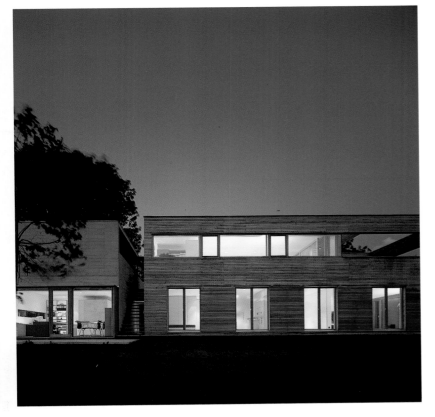

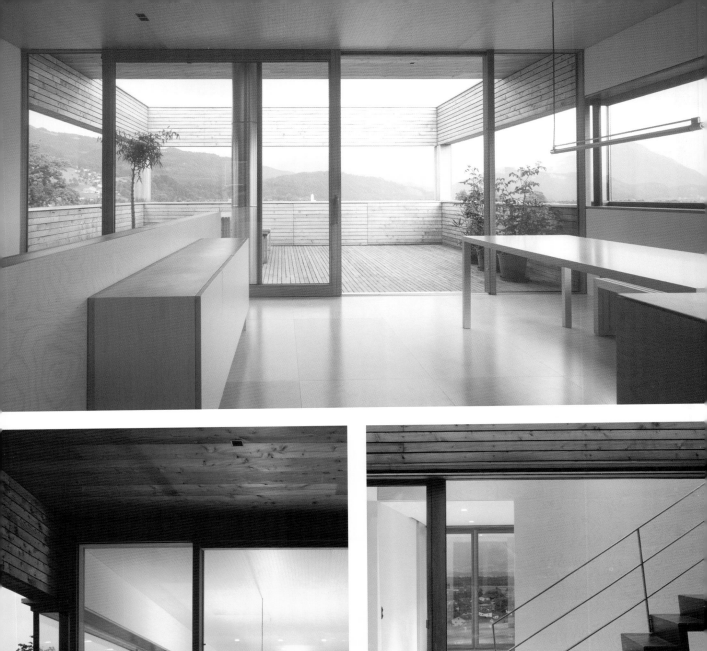
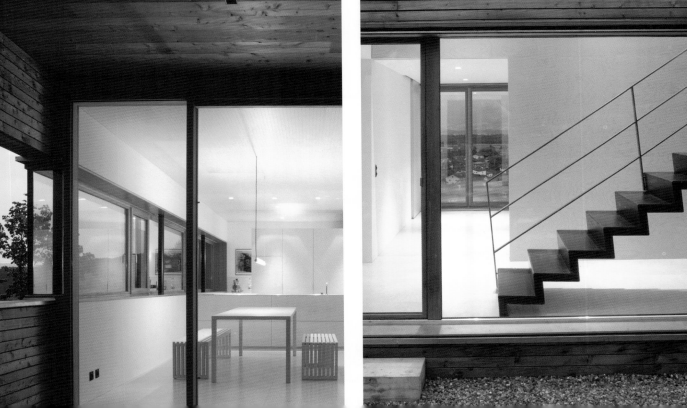

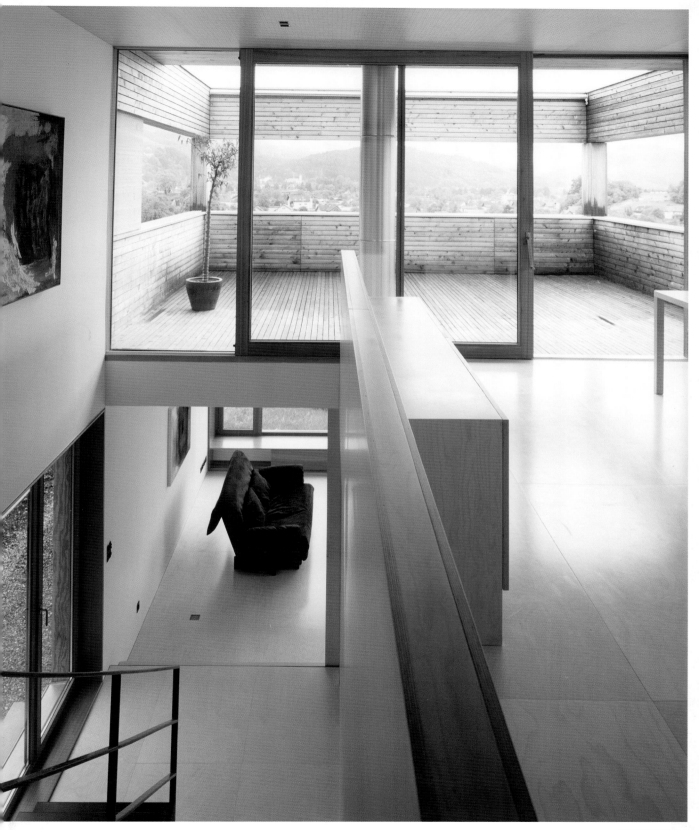

Directory

Affleck + De la Riva Architectes
460 Sainte-Catherine Ouest, Suite 710
Montréal, Québec, H3B 1A7, Canada
T +1 514 861 0133
F +1 514 861 5776
www.affleck-delariva.ca
gavin@affleck-delariva.ca

Blum + Grossenbacher
Aarwangenstrasse 26
CH-4900, Langenthal, Switzerland
T +41 62 923 29 23
F +41 62 923 02 40
www.blum-grossenbacher.ch

MacKay–Lyons Sweetapple Architects Ltd.
2188 Gottingen Street, Halifax
Nova Scotia, B3K 3B4, Canada
T +1 902 429 1867
F +1 902 429 6276
www.bmlaud.ca

Charles Pictet Architecte
13 rue du Roveray
CH-1207 Genève, Switzerland
T +41 22 700 51 35
F +41 22 700 51 07
www.pictet-architecte.ch

Connor + Solomon Architects
Warehouse 5, 37 Nicholson Street
Balmain NSW 2041, Australia
T +61 2 9810 1329
F +61 2 9810 4109
www.coso.com.au

Cukrowicz.Nachbaur Architekten
Rathausstrasse 2
A-6900 Bregenz, Austria
T +43 5574 827 88
F +43 5574 826 88
www.cn-arch.at

E. Cobb Architects Inc.
911 Western Avenue, Suite 318
Seattle, Washington 98104, USA
T +1 206 287 0136
F +1 206 233 9742
www.cobbarch.com

Estudi Arca d'Arquitectura
Gran Via 967, esc. A, 1er 4a
08018 Barcelona, Spain
T +34 933 078 109
F +34 933 076 470
arc@coac.net

Feyferlik/Fritzer Architekten
Glacisstraße 7
A-8010 Graz, Austria
T +43 163 476 56
F +43 163 860 29
feyferlik@inode.at fritzer@iniode.cc

Florian Nagler Architekten
Marsopstraße 8
81245 München, Germany
T +49 89 8 20 05 10
F +49 89 83 92 87 43
info@nagler-architekten.de

Gerold Leuprecht
Dritteläckerweg 9
A-6850 Dornbirn, Austria
T +43 5572 20 47 30
F +43 5572 20 47 39
g.leuprecht@vol.at

Ivan Cavegn Architekturbüro
Schaanerstrasse 40
FL-9490 Vaduz, Liechtenstein
T +423 233 48 13
F +423 233 41 14
i.cavegn@cavegn.li www.cavegn.li

Johannes Kaufmann Architektur
Sägerstrasse 4
A-6850 Dornbirn, Austria
T +43 5572 236 90
F +43 5572 236 90-4
www.jkarch.at

Max Bosshard & Christoph Luchsinger
Mythenstrasse 7
CH-6003 Luzern, Switzerland
T +41 41 227 41 11
F +41 41 227 41 10
blarch@access.ch

Nassar Arquitectes
Trafalgar 17, pral. 1a
08010 Barcelona, Spain
T +34 932 955 800
F +34 932 955 801
nassarq@menta.net

Olson Sundberg Kundig Allen Architects
159 South Jackson Street, 6th Floor
Seattle, Washington 98104, USA
T +1 206 624 5670
F +1 206 624 3730
www.olsonsundberg.com

Salmela Architecture & Design
852 Grandview Av.
Duluth, Minnesota 55812, USA
T +1 218 724 7517
F +1 218 728 6805
dd.salmela@charter.net

Sanaa Ltd./Kazuyo Sejima, Ryue Nishizawa and Associates
7-A Shinagawa-Soko, 2-2-35 Higashi-Shinagawa
Shinagawa-Ku, 140, Tokyo, Japan
T +81 3 34501754
F +81 3 34501757
sanaa@sanaa.co.jp

Markus Wespi Jérôme de Meuron Architekten
Postfach 57
CH-6578, Caviano, Switzerland
T/F +41 91 794 17 73
info@wespidemeuron.ch
www.wespidemeuron.ch